Pro·Lighting

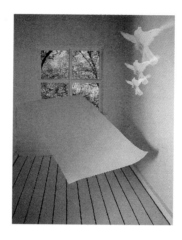

STILL LIFE

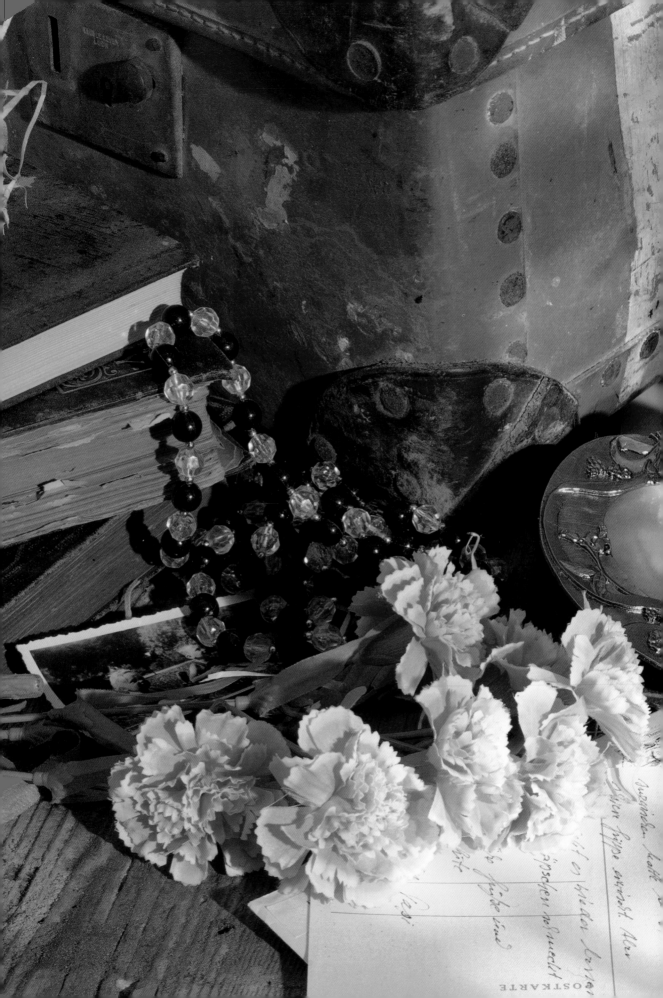

Pro·Lighting

ROGER HICKS and FRANCES SCHULTZ

STILL LIFE

ROTOVISION

A Quarto Book

Published and distributed by:
RotoVision SA
7 rue du Bugnon
1299 Crans
Switzerland

RotoVision SA Sales Office
Sheridan House
112/116A Western Road
Hove, West Sussex BN3 1DD
England
Tel: +44 1273 72 72 68
Fax: +44 1273 72 72 69

Distributed to the trade in the United States:
Watson-Guptill Publications
1515 Broadway
New York, NY 10036

ISBN 2-88046-272-X

This book was designed and produced by
Quarto Publishing plc
6 Blundell Street
London N7 9BH

Creative Director: Richard Dewing
Designer: Ian Loats
Senior Editor: Anna Briffa
Editor: Kit Coppard
Picture Researchers: Roger Hicks and Frances Schultz

Typeset in Great Britain by
Central Southern Typesetters, Eastbourne
Manufactured in Singapore by Teck Wah Paper Products Ltd.
Printed in Singapore by ProVision Pte. Ltd.
Tel: +65 334 7720
Fax: +65 334 7721

CONTENTS

▼

THE PRO-LIGHTING SERIES

▼

THE MOST COMMON RESPONSE FROM THE PHOTOGRAPHERS WHO CONTRIBUTED TO THIS BOOK, WHEN THE CONCEPT WAS EXPLAINED TO THEM, WAS "I'D BUY THAT". THE AIM IS SIMPLE: TO CREATE A LIBRARY OF BOOKS, ILLUSTRATED WITH FIRST-CLASS PHOTOGRAPHY FROM ALL AROUND THE WORLD, WHICH SHOW EXACTLY HOW EACH INDIVIDUAL PHOTOGRAPH IN EACH BOOK WAS LIT.

Who will find it useful? Professional photographers, obviously, who are either working in a given field or want to move into a new field. Students, too, who will find that it gives them access to a very much greater range of ideas and inspiration than even the best college can hope to present. Art directors and others in the visual arts will find it a useful reference book, both for ideas and as a means of explaining to photographers exactly what they want done. It will also help them to understand what the photographers are saying to them. And, of course, "pro/am" photographers who are on the cusp between amateur photography and earning money with their cameras will find it invaluable: it shows both the standards that are required, and the means of achieving them.

The lighting set-ups in each book vary widely, and embrace many different types of light source: electronic flash, tungsten, HMIs, and light brushes, sometimes mixed with daylight and flames and all kinds of other things. Some are very complex; others are very simple. This variety is very important, both as a source of ideas and inspiration and because each book as a whole has no axe to grind: there is no editorial bias towards one kind of lighting or another, because the pictures were chosen on the basis of impact and (occasionally) on the basis of technical difficulty. Certain subjects are, after all, notoriously difficult to light and can present a challenge even to experienced photographers. Only after the picture selection had been made was there any attempt to understand to understand the lighting set-up.

This book is a part of the third series: PORTRAITS, STILL LIFE and NUDES. The first series was PRODUCT SHOTS, GLAMOUR SHOTS and FOOD SHOTS, and the second was INTERIORS, LINGERIE and SPECIAL EFFECTS. The intriguing thing in all of them is to see the degree of underlying similarity, and the degree of diversity, which can be found in a single discipline or genre.

In portraiture, for example, there is a remarkable preference for monochrome and for medium formats, though the styles of lighting are very varied. In nudes, softer lighting is more usual, though the rendition is very often what painters would call "hard edge". And in still lifes, although few manipulated images are shown in the book, many photographers said that they were either already using it or were getting in to it.

In none of the books of the third series, though, is there as much of a "universal lighting set up" as was so often detectable in the first two series. This is probably because all three topics are inclined to be personal pictures, often portfolio shots, and they therefore reflect artistic variety more than commercial necessity.

The structure of the books is straightforward. After this initial introduction, which changes little among all the books in the series, there is a brief guide and glossary of lighting terms. Then, there is specific introduction to the individual area or areas of photography which are covered by the book. Subdivisions of each discipline are arranged in chapters, inevitably with a degree of overlap, and each chapter has its own introduction. Finally, there is a directory of those photographers who have contributed work.

If you would like your work to be considered for inclusion in future books, please write to Quarto Publishing, 6 Blundell Street, London N7 9BH and request an Information Pack. DO NOT SEND PICTURES, either with the initial inquiry or with any subsequent correspondence, unless requested; unsolicited pictures may not always be returned. When a book is planned which corresponds with your particular area of expertise, we will contact you. Until then, we hope that you enjoy this book; that you will find it useful; and that it helps you in your work.

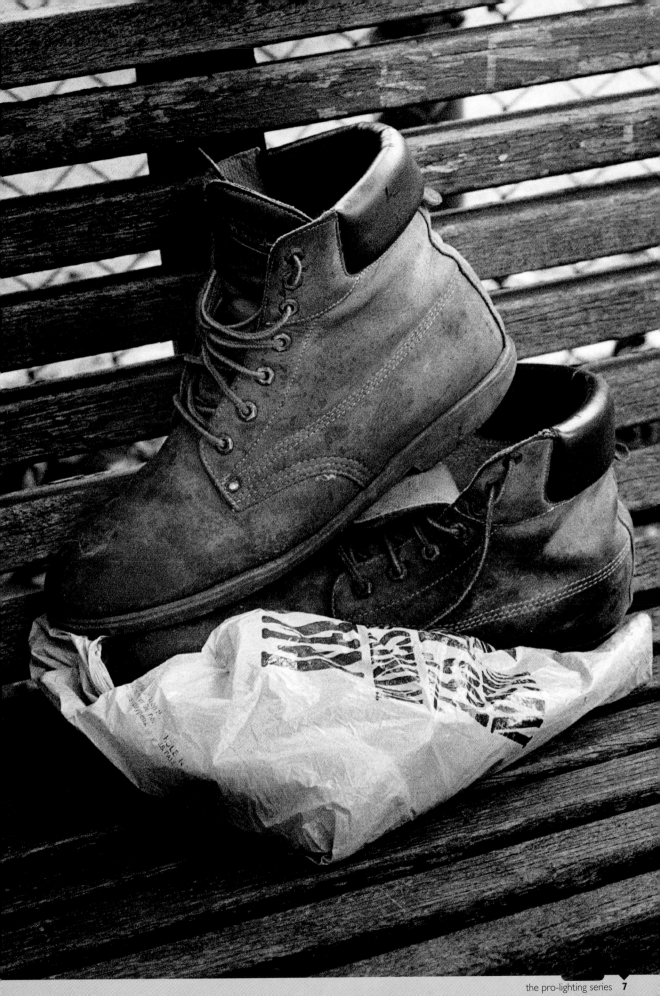

HOW TO USE THIS BOOK

▼

THE LIGHTING DRAWINGS IN THIS BOOK ARE INTENDED AS A GUIDE TO THE LIGHTING SET-UP RATHER THAN AS ABSOLUTELY ACCURATE DIAGRAMS. PART OF THIS IS DUE TO THE VARIATION IN THE PHOTOGRAPHERS' OWN DRAWINGS, SOME OF WHICH WERE MORE COMPLETE (AND MORE COMPREHENSIBLE) THAN OTHERS, BUT PART OF IT IS ALSO DUE TO THE NEED TO REPRESENT COMPLEX SET-UPS IN A WAY WHICH WOULD NOT BE NEEDLESSLY CONFUSING.

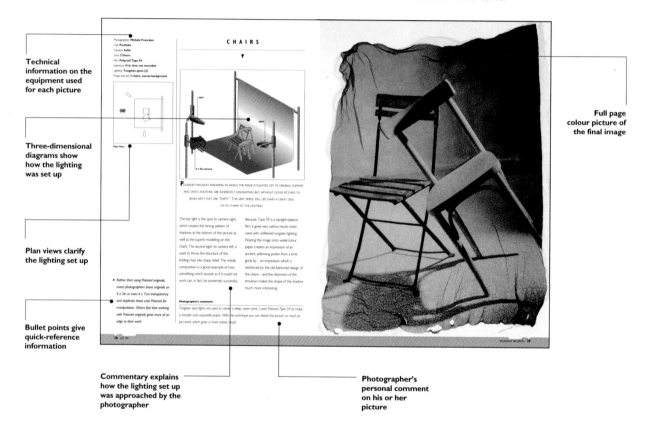

Technical information on the equipment used for each picture

Three-dimensional diagrams show how the lighting was set up

Plan views clarify the lighting set up

Bullet points give quick-reference information

Commentary explains how the lighting set up was approached by the photographer

Photographer's personal comment on his or her picture

Full page colour picture of the final image

Distances and even sizes have been compressed and expanded: and because of the vast variety of sizes of soft boxes, reflectors, bounces and the like, we have settled on a limited range of conventionalized symbols. Sometimes, too, we have reduced the size of big bounces, just to simplify the drawing.

None of this should really matter, however. After all, no photographer works strictly according to rules and preconceptions: there is always room to move this light a little to the left or right,

to move that light closer or further away, and so forth, according to the needs of the shot. Likewise, the precise power of the individual lighting heads or (more important) the lighting ratios are not always given; but again, this is something which can be "fine tuned" by any photographer wishing to reproduce the lighting set-ups in here.

We are however confident that there is more than enough information given about every single shot to merit its inclusion in the book: as well as purely

lighting techniques, there are also all kinds of hints and tips about commercial realities, photographic practicalities, and the way of the world in general.

The book can therefore be used in a number of ways. The most basic, and perhaps the most useful for the beginner, is to study all the technical information concerning a picture which he or she particularly admires, together with the lighting diagrams, and to try to duplicate that shot as far as possible with the equipment available.

A more advanced use for the book is as a problem solver for difficulties you have already encountered: a particular technique of back lighting, say, or of creating a feeling of light and space. And, of course, it can always be used simply as a source of inspiration.

The information for each picture follows the same plan, though some individual headings may be omitted if they were irrelevant or unavailable. The photographer is credited first, then the client, together with the use for which the picture was taken. Next come the other members of the team who worked on the picture: stylists, models, art directors, whoever. Camera and lens come next, followed by film. With film, we have named brands and types, because different films have very different ways of rendering colours and tonal values. Exposure comes next: where the lighting is electronic flash, only the aperture is given, as illumination is of course independent of shutter speed. Next, the lighting equipment is briefly summarized — whether tungsten or flash, and what sort of heads — and finally there is a brief note on props and backgrounds. Often, this last will be obvious from the picture, but in other cases you may be surprised at what has been pressed into service, and how different it looks from its normal role.

The most important part of the book is however the pictures themselves. By studying these, and referring to the lighting diagrams and the text as necessary, you can work out how they were done; and showing how things are done is the brief to which the *Pro Lighting* series was created.

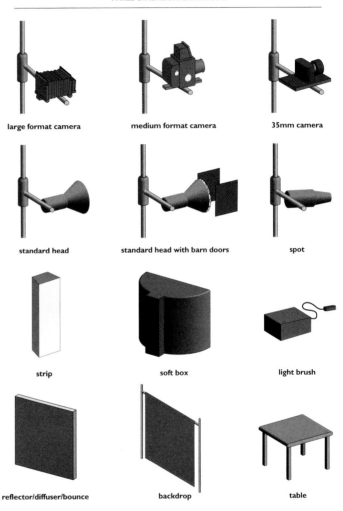

D I A G R A M K E Y

The following is a key to the symbols used in the three-dimensional and plan view diagrams. All commonly used elements such as standard heads, reflectors etc., are listed. Any special or unusual elements involved will be shown on the relevant diagrams themselves.

THREE-DIMENSIONAL DIAGRAMS

large format camera | medium format camera | 35mm camera

standard head | standard head with barn doors | spot

strip | soft box | light brush

reflector/diffuser/bounce | backdrop | table

PLAN VIEW DIAGRAMS

large format camera | medium format camera | 35mm camera | bounce

standard head | standard head with barn doors | spot | gobo

diffuser

reflector

strip | soft box | light brush | backdrop | table

GLOSSARY OF LIGHTING TERMS

▼

LIGHTING, LIKE ANY OTHER CRAFT, HAS ITS OWN JARGON AND SLANG. UNFORTUNATELY, THE DIFFERENT TERMS ARE NOT VERY WELL STANDARDIZED, AND OFTEN THE SAME THING MAY BE DESCRIBED IN TWO OR MORE WAYS OR THE SAME WORD MAY BE USED TO MEAN TWO OR MORE DIFFERENT THINGS. FOR EXAMPLE, A SHEET OF BLACK CARD, WOOD, METAL OR OTHER MATERIAL WHICH IS USED TO CONTROL REFLECTIONS OR SHADOWS MAY BE CALLED A FLAG, A FRENCH FLAG, A DONKEY OR A GOBO — THOUGH SOME PEOPLE WOULD RESERVE THE TERM "GOBO" FOR A FLAG WITH HOLES IN IT, WHICH IS ALSO KNOWN AS A COOKIE. IN THIS BOOK, WE HAVE TRIED TO STANDARDIZE TERMS AS FAR AS POSSIBLE. FOR CLARITY, A GLOSSARY IS GIVEN BELOW, AND THE PREFERRED TERMS USED IN THIS BOOK ARE ASTERISKED.

Acetate
see Gel

Acrylic sheeting
Hard, shiny plastic sheeting, usually methyl methacrylate, used as a diffuser ("opal") or in a range of colours as a background.

***Barn doors**
Adjustable flaps affixed to a lighting head which allow the light to be shaded from a particular part of the subject.

Barn doors

Boom
Extension arm allowing a light to be cantilevered out over a subject.

***Bounce**
A passive reflector, typically white but also, (for example) silver or gold, from which light is bounced back onto the subject. Also used in the compound term "Black Bounce", meaning a flag used to absorb light rather than to cast a shadow.

Continuous lighting
What its name suggests: light which shines continuously instead of being a brief flash.

Contrast
see Lighting ratio

Cookie
see Gobo

***Diffuser**
Translucent material used to diffuse light. Includes tracing paper, scrim, umbrellas, translucent plastics such as Perspex and Plexiglas, and more.

Electronic flash: standard head with parallel snoot (Strobex)

Donkey
see Gobo

Effects light
Neither key nor fill; a small light, usually a spot, used to light a particular part of the subject. A hair light on a model is an example of an effects (or "FX") light.

***Fill**
Extra lights, either from a separate head or from a reflector, which "fills" the shadows and lowers the lighting ratio.

Fish fryer
A small Soft Box.

***Flag**
A rigid sheet of metal, board, foam-core or other material which is used to absorb light or to create a shadow. Many flags are painted black on one side and white (or brushed silver) on the other, so that they can be used either as flags or as reflectors.

***Flat**
A large Bounce, often made of a thick sheet of expanded polystyrene or foam-core (for lightness).

Foil
see Gel

French flag
see Flag

Frost
see Diffuser

***Gel**
Transparent or (more rarely) translucent coloured material used to modify the colour of a light. It is an abbreviation of "gelatine (filter)", though most modern "gels" for lighting use are actually of acetate.

***Gobo**
As used in this book, synonymous with "cookie": a flag with cut-outs in it, to cast interestingly-shaped shadows. Also used in projection spots.

"Cookies" or "gobos" for projection spotlight (Photon Beard)

***Head**
Light source, whether continuous or flash. A "standard head" is fitted with a plain reflector.

***HMI**
Rapidly-pulsed and

effectively continuous light source approximating to daylight and running far cooler than tungsten. Relatively new at the time of writing, and still very expensive.

***Honeycomb**
Grid of open-ended hexagonal cells, closely resembling a honeycomb. Increases directionality of

Honeycomb (Hensel)

light from any head.

Incandescent lighting
see Tungsten

Inky dinky
Small tungsten spot.

***Key or key light**
The dominant or principal light, the light which casts the shadows.

Kill Spill
Large flat used to block spill.

***Light brush**
Light source "piped" through fibre-optic lead. Can be used to add highlights, delete shadows and modify lighting, literally by "painting with light".

Electronic Flash: light brush "pencil" (Hensel)

Electronic Flash: light brush "hose" (Hensel)

Lighting ratio
The ratio of the key to the fill, as measured with an incident light meter. A high lighting ratio (8:1 or above) is very contrasty, especially in colour, a low lighting ratio (4:1 or less) is flatter or softer. A 1:1 lighting ratio is completely even, all over the subject.

***Mirror**
Exactly what its name suggests. The only reason for mentioning it here is that reflectors are rarely mirrors, because mirrors create "hot spots" while reflectors diffuse light. Mirrors (especially small shaving mirrors) are however widely used, almost in the same way as effects lights.

Northlight
see Soft Box

Perspex
Brand name for acrylic sheeting.

Plexiglas
Brand name for acrylic sheeting.

***Projection spot**
Flash or tungsten head with projection optics for casting a clear image of a gobo or cookie. Used to create textured lighting effects and shadows.

***Reflector**
Either a dish-shaped

surround to a light, or a bounce.

***Scrim**
Heat-resistant fabric

Electronic Flash: projection spotlight (Strobex)

Tungsten Projection spotlight (Photon Beard)

diffuser, used to soften lighting.

***Snoot**
Conical restrictor, fitting over a lighting head. The light can only escape from the small hole in the end, and is

therefore very directional.

***Soft box**
Large, diffuse light source made by shining a light

Tungsten spot with conical snoot (Photon Beard)

Electronic Flash: standard head with parallel snoot (Strobex)

through one or two layers of diffuser. Soft boxes come in all kinds of shapes

Tungsten spot with safety mesh (behind) and wire half diffuser scrim (Photon Beard)

Electronic flash: standard head with large reflector and diffuser (Strobex)

and sizes, from about 30x30cm to 120x180cm and larger. Some soft boxes are rigid; others are made of fabric stiffened with poles resembling fibreglass fishing rods. Also known as a northlight or a windowlight, though these can also be created by shining standard heads through large (120x180cm or larger) diffusers.

***Spill**

Light from any source which ends up other than on the subject at which it is pointed. Spill may be used to provide fill, or to light backgrounds, or it may be controlled with flags, barn doors, gobos etc.

***Spot**

Directional light source. Normally refers to a light using a focusing system with reflectors or lenses or both, a "focusing spot", but also loosely used as a reflector head rendered more directional with a honeycomb.

***Strip *or* strip light**

Lighting head, usually flash, which is much longer than it is wide.

Electronic flash: strip light with removable barn doors (Strobex)

Strobe

Electronic flash. Strictly, a "strobe" is a stroboscope or rapidly repeating light source, though it is also the name of a leading manufacturer.

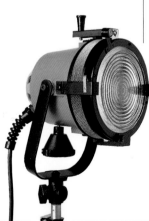

Tungsten spot with removable Fresnel lens. The knob at the bottom varies the width of the beam (Photon Beard)

Strobex, formerly Strobe Equipment.

Swimming pool

A very large Soft Box.

***Tungsten**

Incandescent lighting. Photographic tungsten

Electronic flash: standard head with standard reflector (Strobex)

lighting runs at 3200°K or 3400°K, as compared with domestic lamps which run at 2400°K to 2800°K or thereabouts.

***Umbrella**

Exactly what its name suggests; used for modifying light.

Umbrellas may be used as reflectors (light shining into the umbrella) or diffusers (light shining through the umbrella). The cheapest way of creating a large, soft light source.

Windowlight

Apart from the obvious meaning of light through a window, or of light shone through a diffuser to look as if it is coming through a window, this is another name for a soft box.

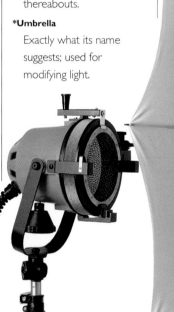

Tungsten spot with shoot-through umbrella (Photon Beard)

STILL LIFE

▼

STILL LIFE IS ONE OF THE HARDEST OF PHOTOGRAPHIC GENRES TO DEFINE. PORTRAITS, NUDES, ARCHITECTURE, LINGERIE, FOOD, EVEN SPECIAL EFFECTS ALL RAISE CERTAIN EXPECTATIONS; BUT STILL LIFE IS ANOTHER MATTER. IT RANGES FROM ADVERTISING SHOTS TO THE MOST PERSONAL OF WORK; FROM PICTURES WHICH CAN TAKE DAYS TO ASSEMBLE IN THE STUDIO, TO THOSE WHICH ARE "FOUND" COMPOSITIONS AND ARE PHOTOGRAPHED BY AVAILABLE LIGHT IN A FEW MOMENTS; FROM SUBJECTS NO BIGGER THAN THE PALM OF YOUR HAND, TO THOSE WHICH FILL A ROOM.

As ever in the *Pro Lighting* series we have endeavoured to provide a mix of images which display as wide a range of lighting techniques as possible, while still remaining worthwhile and attractive pictures. Inevitably, some are more exciting than others – but if you take time to look at some of the less immediately arresting pictures instead of flipping past them, you will find, first, that there is more to them aesthetically than meets the eye; and, second, that the lighting techniques are often very cleverly deployed. Others, which are real show-stoppers, may on occasion turn out to be quite unexpectedly simple: proof, if any were needed, that it is the photographer's eye which is the truly creative force, and that technique is only a handmaiden. In the words of Jeff Procopowicz, "a great picture which is technically great is a great picture, and a great picture which is technically flawed is still a great picture, too."

You will not find technical flaws in here – at least, you should not – but you will find pictures which deliberately use "flaws" or "limitations" in the photographic process to create memorable and highly attractive pictures. You will also find pictures which are as close to technical

perfection as can be imagined – but this, of course, is taken for granted.

Another thing you will not find in this book is the kind of still life which was so popular in the late 18th century and most of the 19th: the grand set piece, typically centred on a dead pheasant and characterized by dramatic chiaroscuro. Nor are there very many bowls of fruit or other food-based pictures. This rather surprised us as we eagerly opened each new batch of submissions. We had expected to see such pictures, and indeed we would very much like to have seen more; but they simply did not come in. It seems that there is a shift away from this sort of still life, to – well, to what you can see for yourself in these pages.

WHY STILL LIFE?

We believe – though we can never be sure – that the *Pro Lighting* series has equal (though different) attractions for both professionals and amateurs. Professionals buy the books for ideas, and to see what their fellow professionals are doing. It is no exaggeration to say that everyone who reads this book will learn something from it – and, for a professional, a single new idea may be well worth the purchase price of the

book. It is not that professionals are so short of new ideas that they need to buy books like this: it is that new ideas have to be sparked by something, and looking at other photographers' work is a good way to spark them. If there are technical details as well, so much the better: often, it will be a matter of applying a technique from these pages to an idea which may have been fermenting quietly for a long time, so that seeing someone else's picture finally gives you the impetus to try to realize your own idea.

In many ways, though, the amateur has more to gain because he (or she) can learn more; and this is particularly true of still life. As a genre, it is far less popular than it used to be among amateurs, and yet it is no less rewarding than ever it was. Admittedly, many people in this busy modern world may feel that they do not have the time to work in the slow, reflective way which characterizes many still life photographers; but what they may not realize is that there can be an almost meditative aspect to still life photography which is very calming and relaxing; and, better still, if you get it right you have a permanent reminder in the form of a picture.

Meditative it may be, but this is not

necessarily the same as easy or even relaxed. Getting the right props, in the right position, with the right lighting is time-consuming and can on occasion be frustrating; but equally, "giving it a good coat of think" brings the satisfaction of overcoming difficulties and proving (to yourself if to no-one else) that you can master your subject. Also, it does not all have to be done at once: you can leave a still life for hours, or even days, and then come back to it when you have a better idea.

STUDIOS AND SETTINGS

A basic problem for the amateur – and indeed for the professional, if other work demands the same space – is the opportunity to leave a still life substantially set up, whether overnight or for longer. On the bright side, though, many still lifes require very little space for themselves: even a dining room table may be big enough. The lights and the camera can be removed and replaced, if need be, without disturbing the essential integrity of the composition, though a Polaroid reference shot of the set-up can be a useful *aide-mémoire* when it comes to re-creating the lighting and the camera angle. So, for that matter, can Polaroid taken before the composition, lighting, etc., are finalized.

It can also be a useful exercise to go looking for "found" still lifes; that is, for compositions which present themselves in everyday life. One photographer might find inspiration in the garden, with rusty watering-cans and weathered planters. Another might see pictures in the kitchen, whether in well-worn utensils or in the sleek lines of something new.

CAMERAS, LENSES AND FILM

Surprisingly many (12 per cent) of the still lifes in this book were shot with 35mm, and exactly the same percentage was shot with roll-film; but rather over half were shot on 4 × 5in, and almost 20 per cent were shot on 8 × 10in. Just one was shot in 13 × 18cm (5 × 7in).

This preponderance of cut film reflects a number of things. One is the ease of focusing and (still more) of composing on a big ground glass. Another is the usefulness of camera movements. Studio-based still life photographers are normally addicted to monorails, with all the movements they can get, including back rise and cross. As one said, "Large format cameras are for lazy photographers – you can always get the effect you want, one way or another." Yet a third reason is the way in which large formats can both render texture and "see into the shadows". The former is fairly easy to understand – 8 × 10in, in particular, can capture texture in a way which all but defies belief – while the latter is easy to recognize but hard to explain.

The popularity of cut film also reflects the fact that, normally, still life photographers spend more time setting up their shots than they do in actually shooting. Often, as few as two sheets of film may be the fruit of several hours' or even days' setting up, though many still life photographers will shoot a few spares if they suspect that the picture may be useful for more than one application. A reportage photographer simply could not afford to shoot 4 × 5in with the profligacy which is required by modern newspapers, even if he could carry the weight.

Polaroids are however of fundamental importance to most still life photographers. Today it is quite usual to work towards precisely the right set-up and lighting by using several generations of Polaroids, and once again, this explains why 4 × 5in is so popular: the Polaroids are big enough to see (even 6 × 7cm Polaroids are pretty marginal for detailed analysis), but they are also affordable. After all, an 8 × 10in Polaroid costs close to three times as much as a 4 × 5in Polaroid, and even if you use only half a dozen Polaroids this can add up to a fairly significant expense. Some major photographers freely admit that, if cost was no object, they would shoot almost exclusively on 8 × 10in, but budgetary constraints force them to use 4 × 5in.

This may also explain why relatively few amateurs shoot still lifes: 4 × 5in is still not widely regarded as an amateur format, though it seems to be gaining ground surprisingly rapidly. This may be a reaction to automation and electronics: an old-fashioned large-format camera is by no means idiot-proof, but if you are not an idiot it gives you unparalleled opportunities for quality and control.

As for film, in this book it is very much a question of "the usual suspects": Kodak Ektachrome (mostly ISO 64 and ISO 100), Fuji RDP and RDP II ISO 100 and Fuji Velvia. There are also a couple of Kodachromes, some Polaroid originals, one or two colour negatives and even a Scotch 1000. Because close control of colour is normally possible in the studio, using CC filters if necessary, and because grain and sharpness are not really an issue at 4 × 5in and above, choice of film is commonly determined by habit; by

how much saturation and contrast are needed; and by availability.

Interestingly, very few monochrome pictures were submitted for inclusion in this book – in marked contrast, for example, to *Portraits* and *Nudes*, which were in production at the same time. The monochrome still life is, on the evidence of this book, an endangered species.

LIGHTING EQUIPMENT FOR STILL LIFE

The lighting set-ups in this book range from daylight to elaborate multi-head set-ups using considerable amounts of power. There is little point in attempting to make generalizations because the different photographers' approaches are so widely varied, but it is worth noting that over half the pictures in this book used only one or two lights, while only about 15 per cent used four or more lights. With two heads, preferably with two soft boxes in case of need, you can do a remarkable amount.

What is more, there is not even a pressing need for a great deal of power in many cases, as you can often use multiple "hits" of flash: several pictures in this book were taken this way, although most of them reflect the fact that very small apertures were in use with 8 x 10in cameras. If a particular set up gives you only f/11, though, and you want to shoot at f/22, then four "hits" will give you the aperture you need; eight "hits" will give you f/32.

If you want to adopt this approach, you may care to investigate "press" or "everset" shutters, which do not need to be re-cocked: we had one of our lenses re-mounted in a self-cocking shutter for precisely this purpose.

THE TEAM

It is quite possible to work on your own, but it is often vastly easier to work with an assistant who can move things while you look at the image on the ground-glass. Amateurs can press wives, children or friends into service without necessarily demanding too much of their time: the assistant spends most of his or her time doing nothing, but when they are needed they are indispensable.

Some still life photographers work with stylists, and others are heavily reliant on model-makers and set-builders, but it is worth remembering that in both cases the photographer has to work out what he wants and (in broad terms) how it needs to be done: the job of stylists, model-makers and set-builders is to execute his vision to the highest possible standard.

SHOOTING STILL LIFES

We have already covered most of this in what we have written above. Commercial still lifes can be subject to the same pressures as any other form of commercial photography, but (as ever) a good percentage of the pictures in this book were shot by professional photographers just for the fun of it – for their portfolios, for self-promotion, and to explore new ideas and new techniques. Including those pictures which were originally shot for these reasons and which were subsequently used commercially, about half the pictures in the book were not specifically commissioned; and even where they were specifically commissioned, there must be another five or ten at least where the photographer was not

working to a "scamp" or a rigid brief but was given a free hand to develop his or her personal vision.

In other words, shooting still lifes is technically demanding, but it is also fun; which is one of the things, surely, which keeps us all interested in photography.

1

inspired by
objects

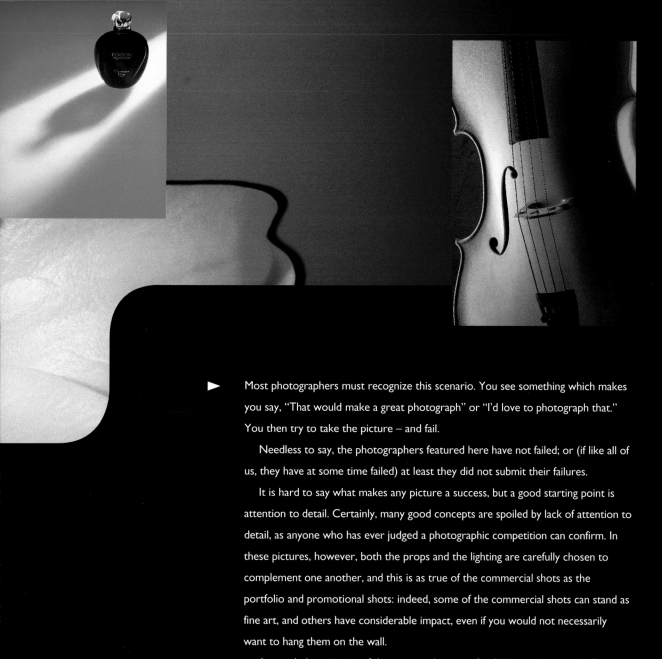

Most photographers must recognize this scenario. You see something which makes you say, "That would make a great photograph" or "I'd love to photograph that." You then try to take the picture – and fail.

Needless to say, the photographers featured here have not failed; or (if like all of us, they have at some time failed) at least they did not submit their failures.

It is hard to say what makes any picture a success, but a good starting point is attention to detail. Certainly, many good concepts are spoiled by lack of attention to detail, as anyone who has ever judged a photographic competition can confirm. In these pictures, however, both the props and the lighting are carefully chosen to complement one another, and this is as true of the commercial shots as the portfolio and promotional shots: indeed, some of the commercial shots can stand as fine art, and others have considerable impact, even if you would not necessarily want to hang them on the wall.

As usual, the majority of the pictures (six out of eight) were shot on 4 x 5in, with one each on 6 x 6cm and 8 x 10in. Two useful exercises are, first, to look at the pictures and ask yourself how you would have tried to convey the same ideas; and, second, to try to duplicate (or at least emulate) any which you particularly admire: as Robert Louis Stevenson said of writing, learning to imitate the people whose work you admire is an essential part of developing your own style, and this is as true of pictures as of words.

GAS GRIP AND WRENCH

▼

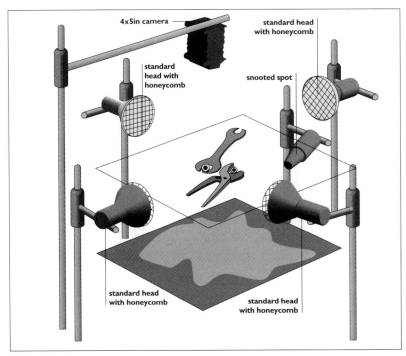

Photographer: **Ben Lagunas & Alex Kuri**

Client: **Meyer & Meyer**

Use: **Poster and magazine campaign**

Assistants: **Isak de Ita and George Jacob**

Art director: **Hans-Paulfreish**

Stylist: **Michel**

Production: **BLAK Productions**

Camera: **4x5in**

Lens: **210mm**

Film: **Kodak Ektachrome EPP ISO 100**

Exposure: **f/16**

Lighting: **Electronic flash: 5 heads**

Props and set: **Glass sheet, black velvet**

THIS IS ONE OF THOSE SHOTS WHICH LOOKS COMPARATIVELY EASY — UNTIL YOU HAVE TO SHOOT IT. YOU COULD WORK ON IT FOR AGES, EVEN IF YOU HAD A CLEAR IDEA OF HOW TO DO IT.

Four directional honeycombed heads provide bright rim-lighting, with highlights and shadows (or, more accurately, bright areas and less bright areas). If the tools were absolutely uniformly lit they would lack three-dimensionality and the superb texture would be lost. A large sheet of flawless and sparkling-clean plate glass supports the tools: setting them down without marking the glass is difficult in its own right. The four rim lights are positioned to give the most attractive effect. Finally, on the black background 1m (40 inches) behind the glass (and therefore well out of focus) a snooted spot adds a subtle purple-blue in the jaws of the gas grips.

Photographer's comment:

The art director wanted only the silhouette and we had to light very carefully to achieve this goal.

- Rim-lighting on a glass sheet can be remarkably effective

- The glass must be flawless and sparkling clean

- Projecting a colour onto a black background may be subtle, but it can be made to read

Plan View

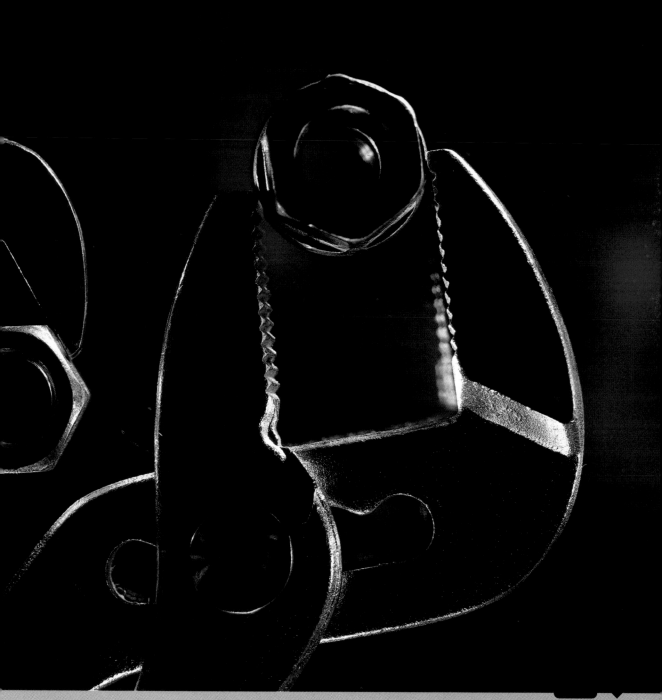

Photographer: **Rudi Mühlbauer**

Use: **Exhibition**

Camera: **6x6cm**

Lens: **50mm with 80A (daylight/tungsten) filter**

Film: **Kodak Vericolor HC ISO 100/21**

Exposure: **1/30sec at f/16**

Lighting: **Tungsten: 2 heads**

Props and set: **Polaroid camera, junk food**

Plan View

F A S T F O O D

▼

PHOTOGRAPHY IS SOMETIMES LIKE POETRY: UNEXPECTED JUXTAPOSITIONS SEEM, ONCE YOU HAVE SEEN THEM, TO BE INEVITABLE. RUDI MÜHLBAUER THOUGHT OF THIS AS HE WAS SLOUCHING TOWARDS McDONALD'S WITH HIS POLAROID CAMERA

Unexpectedly, the light is tungsten and there are no soft boxes. The key is a 500W spot to camera right, alongside the camera and illuminating the subject almost frontally: look at the shadows on the McDonald's cup. This kind of lighting is excellent for adding sparkle and clear delineation in subjects like the front of the camera, which otherwise may read very poorly. It also lights the "flash". Fill, which helps to illuminate the Polaroid print, comes from a 1000W flood to camera right and almost at right angles to the line of sight. This admittedly has a very different quality from a spot or a reflector head, but even so the light is surprisingly soft.

► *With a small, tight composition like this, even the relatively modest area of a tungsten flood (diffused if need be) can act almost like a soft box*

► *Conversion filters are a perfectly acceptable alternative to tungsten-balanced films*

Photographer's comment:

You can get these Polaroid pictures, as fast and as colourful as any hamburgers, to satisfy your little hunger.

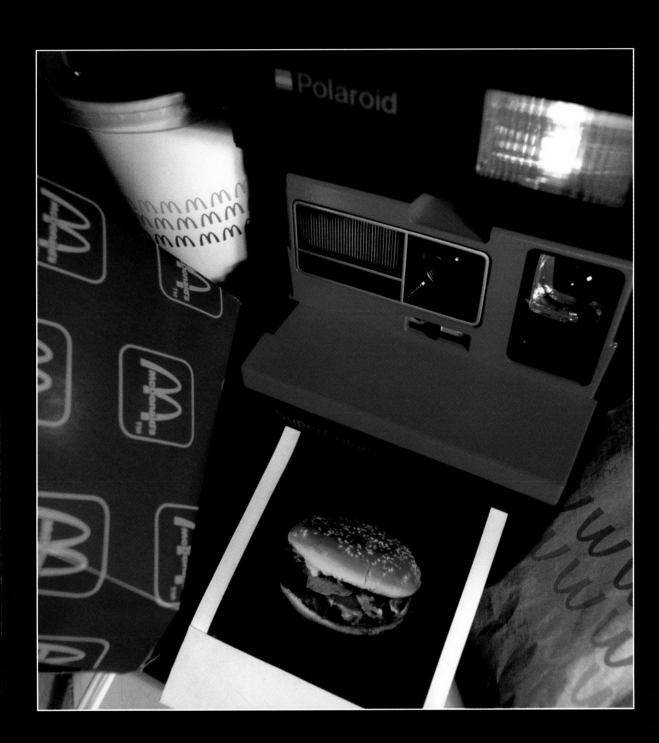

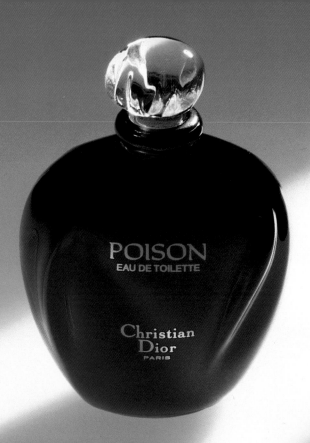

Photographer: **Massimo Robecchi**

Client: **Mondadori Editore**

Use: **Editorial**

Assistant: **Teresa La Grotteria**

Camera: **4x5in**

Lens: **240mm**

Film: **Kodak Ektachrome 6105**

Exposure: **f/16**

Lighting: **Electronic flash: 2 heads**

Props and set: **White plexiglass, Lee blue filter**

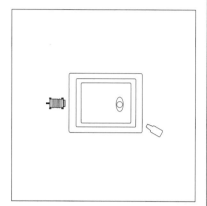

Plan View

▼

soft box

spot

4x5in camera

filter

AT FIRST SIGHT THIS IS A SIMPLE BACK LIT SHOT OF A BOTTLE OF PERFUME ON A PIECE OF BLUE PAPER. THEN YOU START WONDERING HOW MASSIMO ROBECCHI ACHIEVED THAT LUMINOUS QUALITY. THE ANSWER IS QUITE SIMPLE – BUT ALSO QUITE UNEXPECTED.

The bottle is standing on a sheet of white opaline acrylic, which in turn is on top of a blue Lee filter, which in turn is on top of a 60 × 100cm (24 × 40in) soft box with 3200 Joules going through it. The other light is a Superspot, also 3200 Joules, coming from camera right, as clearly seen in the picture. That is all. The highlights in the bottle are all the result of transillumination by the spot. To obtain this subtlety of gradation in any other way would be extremely difficult.

► *There are many grades of white acrylic sheeting, from "translucent" to "opaline" to "opaque". The only way to find which is best is to try them*

► *Transilluminated backgrounds are normally used for shadowless lighting, but that is not the only application*

► *Reduce reflections (if necessary) with a layer of Kodatrace or similar frosted sheeting over polished acrylic*

Photographer's comment:

There are no frontal lights: the white lights on the bottle are from the back light.

Photographer: **Ron McMillan**

Use: **Portfolio**

Assistant: **Paul Cromey**

Camera: **4x5in**

Lens: **210mm (+ orange filter + Softar + 81B)**

Film: **Fuji Provia 100/Mono not recorded**

Exposure: **f/32⅓**

Lighting: **Electronic flash: 2 heads**

Props and set: **Props arranged on old door**

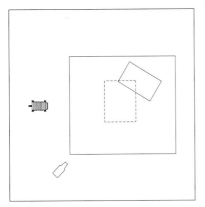

Plan View

▼

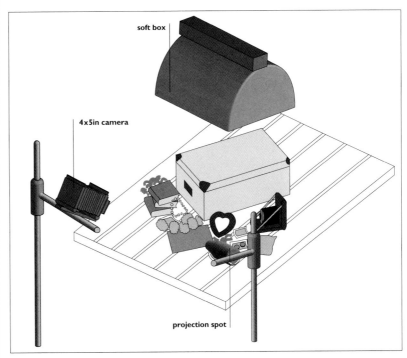

soft box

4x5in camera

projection spot

WHEN YOU SET UP AN ELABORATE PORTFOLIO SHOT IT OFTEN SEEMS TO MAKE SENSE TO SHOOT IT IN BOTH MONOCHROME AND COLOUR; BUT ONLY RARELY DOES IT "WORK" EQUALLY WELL IN MORE THAN ONE MEDIUM.

Each shot has a slightly different camera angle and crop. The lighting in both cases however is identical – again, this is unusual because you often need different lighting ratios in colour and monochrome – and consists of a soft box overhead and a projection spot some distance from the subject and to camera right. This throws the image of the "window" onto the postcard as well as illuminating the camera.

For the colour shot the filtration is chosen to re-create the warm, hazy, dusty sunlight which filters through an attic window; in the monochrome shot, only the soft-focus screen has any real effect. The hand-coloured image is almost more realistic than the full-colour shot: it represents things less as they are, and more as we remember them.

► *Lighting for monochrome can often be more contrasty than for colour because of the greater tonal range which can be acceptably represented on a black and white print*

► *Hand colouring often presents an opportunity for more "naturalistic" colouring than colour film: look at the flowers*

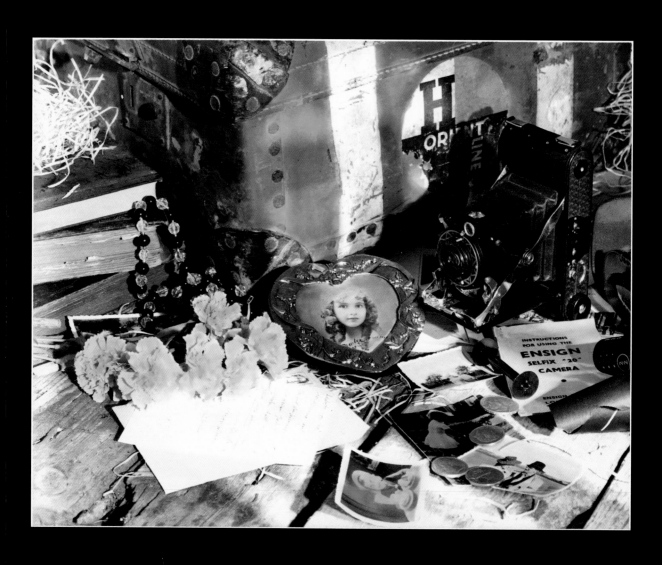

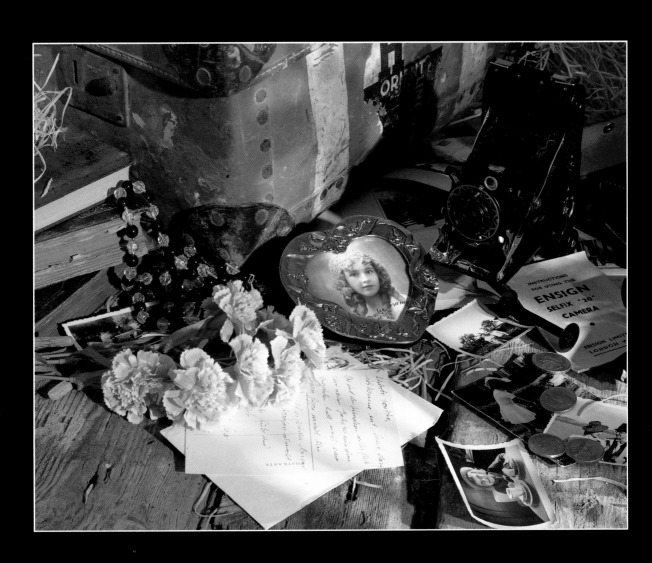

F L O W E R

▼

Photographer: **Terry Ryan**

Client: **Camel Advertising**

Use: **Corporate brochure**

Assistant: **Nicholas Hawke**

Art director: **Shaun Friend**

Camera: **4x5in**

Lens: **210mm**

Film: **Kodak Ektachrome EPP ISO 100/21**

Exposure: **Double exposure**

Lighting: **Electronic flash: 3 heads**

Props and set: **Transmitting light table, black velvet**

THERE ARE TWO EXPOSURES HERE. FOR THE FIRST THE FLOWER WAS EXPOSED AGAINST A BLACK VELVET BACKGROUND; FOR THE SECOND THE VELVET WAS REMOVED AND THE FLOWER WAS PHOTOGRAPHED UNLIT AGAINST A TRANSILLUMINATED BACKGROUND.

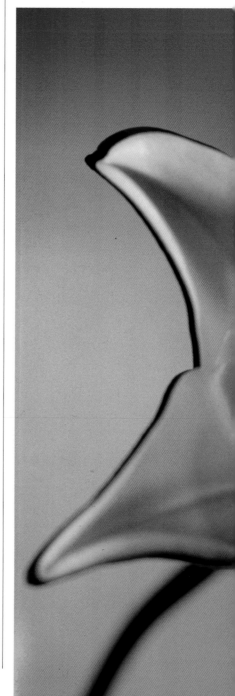

Between the two exposures the lens was refocused a little, which changed the size of the flower in the image and created the black surround – which looks like a shadow but isn't.

The light on the flower is a snooted spot to camera left and above the camera, giving strongly directional lighting and good texture. The background is transilluminated with two spots, each with coloured gels, one cerise, one red.

As with so many shots in the *Pro Lighting* series, this is surprisingly simple and obvious once you know how it was done. You may even be able to work out how it was done just by looking at the picture. But the trick lies in thinking of the idea in the first place.

Photographer's comment:

The art director needed something a little different and a more graphic image using shapes and colours yet still leaving the subject matter recognizable.

► *Refocusing the camera between double exposures changes the image size*

► *Black velvet records about five stops darker than a mid-tone and will normally read as a pure black on colour film*

Plan View

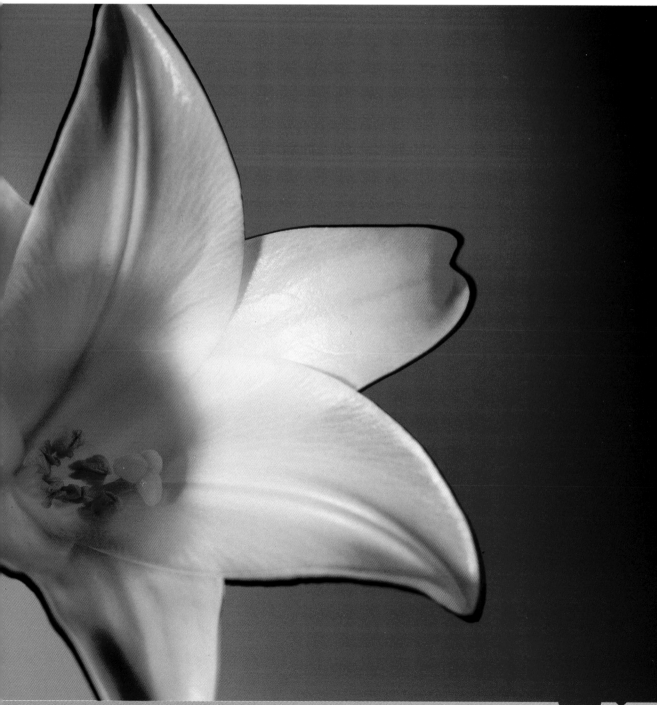

P O I S O N

▼

Photographer: **Ron McMillan**

Client: **Rentokil**

Use: **Advertising**

Camera: **4x5in**

Lens: **210mm**

Film: **Fuji Provia 100**

Exposure: **f/32**

Lighting: **Electronic flash: 1 head**

Props and set: **Old wooden door; bottles**

spot

white bounce

4x5in camera

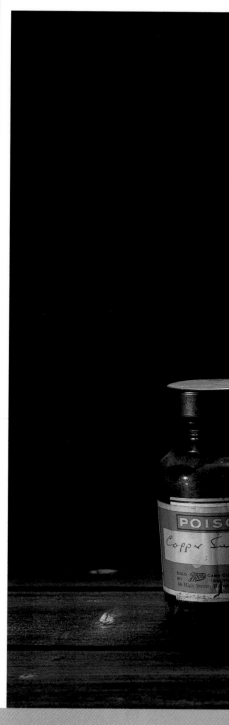

THE IMAGE IS FAMILIAR: A DUSTY SHELF, DEEP IN A SHED, ILLUMINATED BY A RAY OF SUN. THE ONLY CATCH IS THAT, TO EVOKE SOMETHING SIMPLE, YOU HAVE TO DO IT PROPERLY.

A good part of the success of the shot is down to prop hunting: the dirty bottles, the labels, the broken-off corks. The POISON labels, and the internationally-understood skull-and-crossbones, are all the more effective for being clearly stated on the two left bottles. The others could contain anything . . .

The lighting, although simple, matches the mood. There is a single spot light from camera left, the precise position of which is revealed by the highlight on the leftmost bottle, and there is a white bounce overhead. After that it is a matter of adjusting both the angle and the height of the light, and of moving the bottles so that they catch the light best.

► Lighting bottles is always to some extent unpredictable: until you try it, you do not know how much light they will transmit, and how much they will reflect

► A black velvet background creates the illusion of dark recesses behind the bottles

Plan View

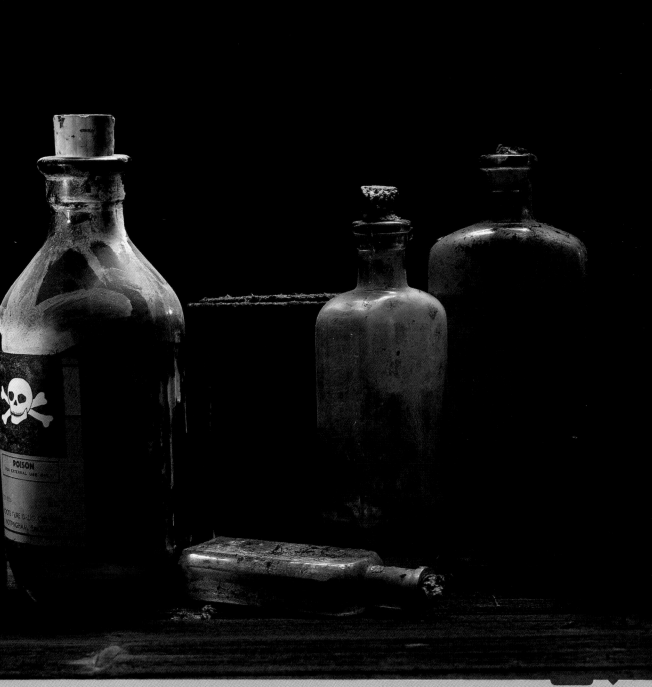

Photographer: **Maurizio Polverelli**

Use: **Portfolio**

Camera: **8x10in**

Lens: **300mm (+ Vaseline filter for second exposure)**

Film: **Kodak Ektachrome 6117, ISO 64/19**

Exposure: **Not recorded; double exposure**

Lighting: **Electronic flash: 2 heads**

Plan View

THE ELEGANCE OF MUSIC

▼

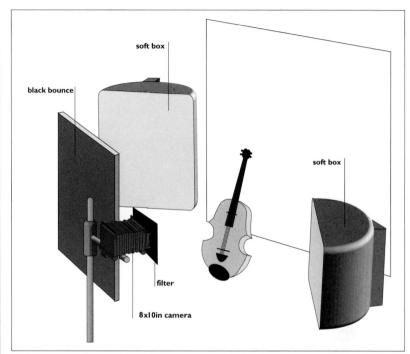

THE TWO LIGHTS SHOWN IN THE DIAGRAM WERE USED SEQUENTIALLY: THE FIRST (THE LARGE SOFT BOX TO CAMERA LEFT) WITHOUT ANY FILTRATION, AND THE SECOND (THE SMALLER SOFT BOX TO CAMERA RIGHT) WITH A VASELINE-SMEARED FILTER OVER THE LENS.

Both lights are carefully set to give the maximum impression of roundness. The left-hand set up uses the combination of an oblique soft light and a black bounce: the effect is similar to that of a strip, but subtly different in quality. Note particularly the emphasis on the moulding around the edge. The right-hand exposure better emphasizes the "belly" of the violin and the depth of the side: camera movements were used to control depth of field.

With either single or double exposures, soft focus effects are easier to achieve on large and very large formats: the greater the degree of enlargement, the harder it is to predict how the soft focus effect will be emphasized.

► *Making two exposures, one after the other, allows filtration or diffusion to be introduced for part of the overall exposure*

► *The technique of using a large soft box and a black bounce gives a unique quality of light*

Photographer's comment:

Only light can exalt the elegance of a violin. On the right side I wanted a mystical atmosphere, which I achieved with a soft-focus exposure and some fuzziness. The large format helps to capture the warm feeling of the wood.

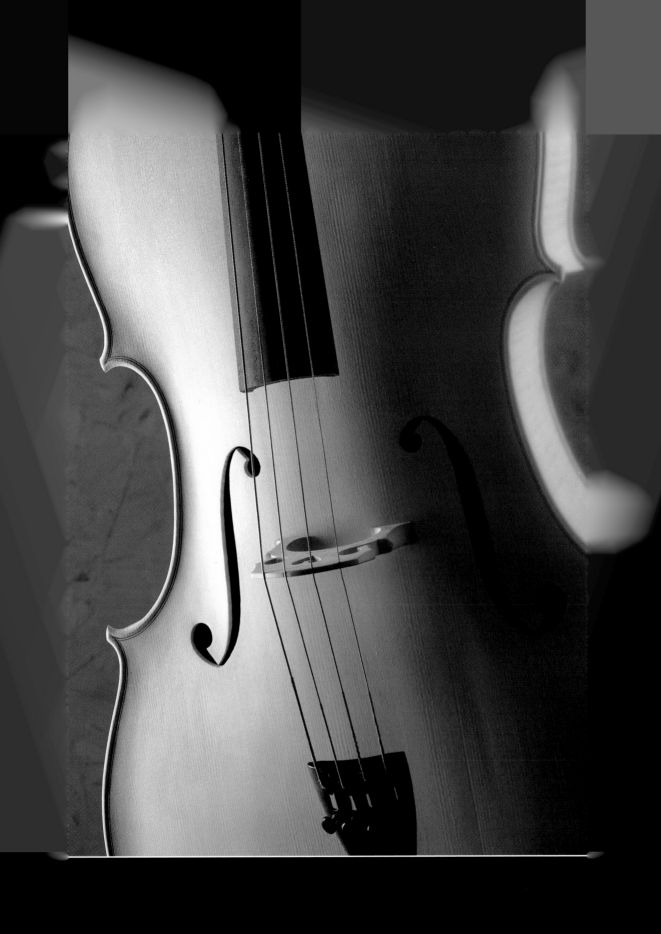

inspired by c

Photographer: **James DiVitale**

Use: **Shot for self-promotion; put into stock;**
used by printing company

Designer: **Sandy DiVitale**

Camera: **4x5in**

Lens: **210mm**

Film: **Kodak Ektachrome EPP ISO 100**

Exposure: **f/32**

Lighting: **Electronic flash: 2 heads**

Plan View

▼

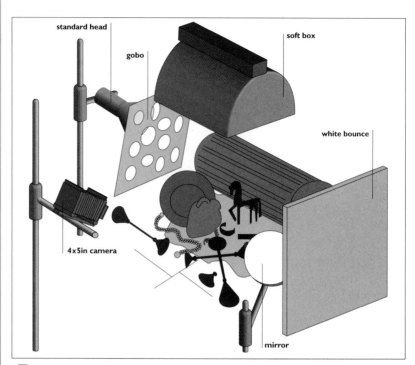

standard head · gobo · soft box · white bounce · 4x5in camera · mirror

THE AIM OF THIS PICTURE WAS TO RECREATE THE IMPRESSION OF AN ARCHAEOLOGICAL DIG, WITH LIGHT COMING THROUGH THE ENTRANCE TO A CAVE OR TOMB. A SIMPLE ENOUGH CONCEPT – UNTIL YOU TRY TO REALIZE IT.

Jim DiVitale began with a standard head to camera left: the shadows make its position clear. Between the light and the subject, however, he interposed a sheet of black card with holes cut in it: in effect, a giant gobo or cookie. This was the key light. Above the set a soft box provided some fill but was set well down from the key in order to preserve the shadows. A sheet of foam core to camera right acted as a general bounce, but a mirror on a boom arm was necessary to throw some more light back onto the underside of the pot. Small mirrors, bounces and reflectors are more widely used in still life photography than many people realize.

► *Shaving mirrors and make-up mirrors can function as small, precise effects lights*

► *Small bounces and flags – the size of a cigarette packet or smaller – can add highlights and shadows*

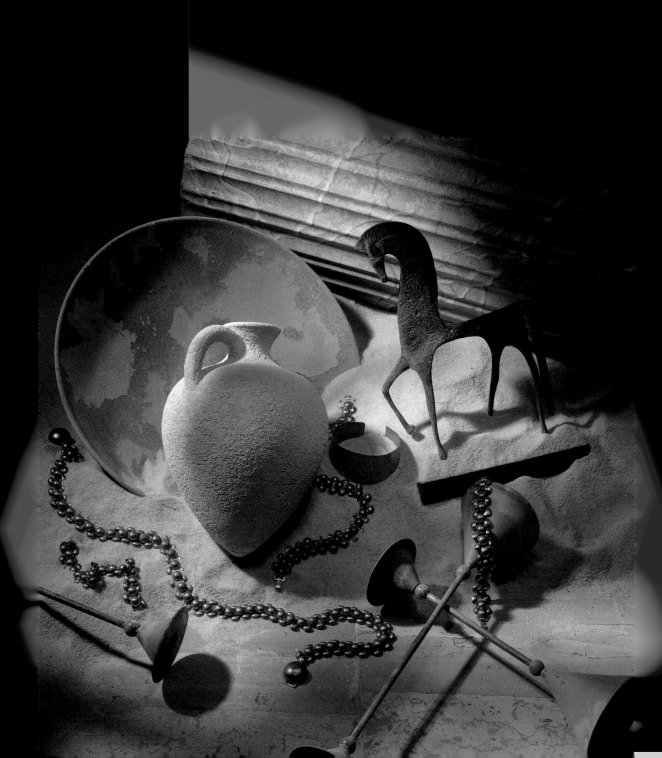

2

deceptive
Simplicity

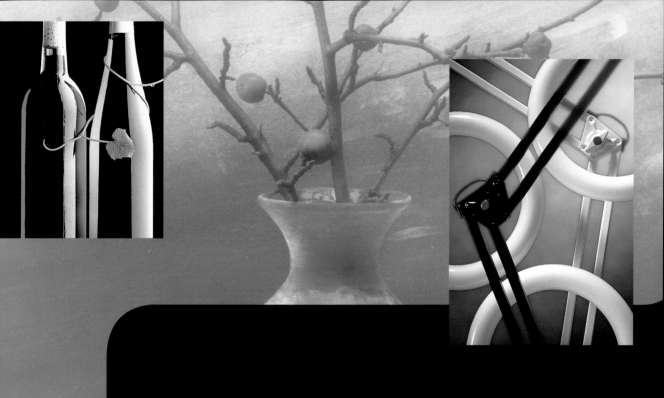

The dictum "less is more" has been attributed to many people (Le Corbusier is a strong contender). It is a phrase which irritates some people beyond measure, while others have an immediate and instinctive understanding of it: a few elements, handled with assurance, will almost always have more immediate impact and elegance than something more complex, no matter how competently those multiple elements are handled. Consider Picasso's head of a bull, made from a bicycle saddle and handlebars, and his *Guernica*: both great works, but the bull is far more immediately accessible in terms of line and form, and it carries no historical baggage in terms of the Spanish Civil War, bombing raids, or the like.

The pictures in this chapter are clear examples of "less is more," of simple picture elements masterfully handed. Often they sound decidedly unpromising – and many of us, if we were handed the subject matter and asked to arrange it into an attractive picture, would immediately feel our hearts sink. And yet these photographs are curiously akin to those in the last chapter: suddenly, we see an apparently unpromising subject in (literally) a new light, and we make a determined effort to recapture that little flash of whatever-it-is which enables us to see the extraordinary in the ordinary.

Again, six of the nine pictures were shot on 4 x 5in, with one each on roll film, 13 x 18cm and 8 x 10in. In most cases, the lighting is as deceptively simple as the subject, but there are also times when a deceptively simple result has been achieved only at the expense of some effort in lighting.

Photographer: **Michèle Francken**

Use: **Portfolio**

Camera: **4x5in**

Lens: **210mm**

Film: **Polaroid Type 59**

Exposure: **f/16; time not recorded**

Lighting: **Tungsten spots (2)**

Props and set: **2 chairs, canvas background**

Plan View

C H A I R S

▼

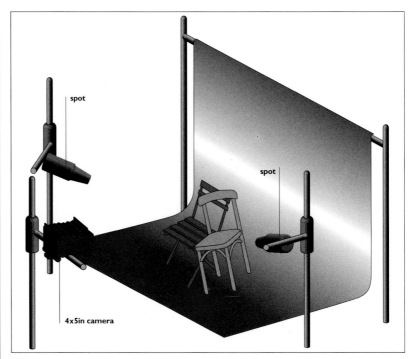

POLAROID EMULSION TRANSFERS, IN WHICH THE IMAGE IS FLOATED OFF ITS ORIGINAL SUPPORT
AND ONTO ANOTHER, ARE INHERENTLY FASCINATING; BUT WITHOUT GOOD PICTURES TO
BEGIN WITH THEY ARE "EMPTY." THIS VERY SIMPLE STILL LIFE OWES A GREAT DEAL
OF ITS CHARM TO THE LIGHTING.

The key light is the spot to camera right, which creates the strong pattern of shadows at the bottom of the picture as well as the superb modelling on the chairs. The second light, to camera left, is used to throw the structure of the folding chair into sharp relief. The whole composition is a good example of how something which sounds as if it could not work can, in fact, be extremely successful.

Because Type 59 is a daylight-balance film, it gives very yellow results when used with unfiltered tungsten lighting. Floating the image onto watercolour paper creates an impression of an ancient, yellowing poster from a time gone by – an impression which is reinforced by the old-fashioned design of the chairs – and the distortion of the emulsion makes the shape of the shadow much more interesting.

Photographer's comment:

Tungsten spot lights are used to create a deep, warm tone. I used Polaroid Type 59 to make a transfer onto aquarelle paper. With this technique you can distort the picture as much as you want, which gives a more artistic result.

► *Rather than using Polaroid originals, many photographers shoot originals on 4 x 5in or even 6 x 7cm transparency and duplicate these onto Polaroid for manipulation. Others feel that working with Polaroid originals gives more of an edge to their work.*

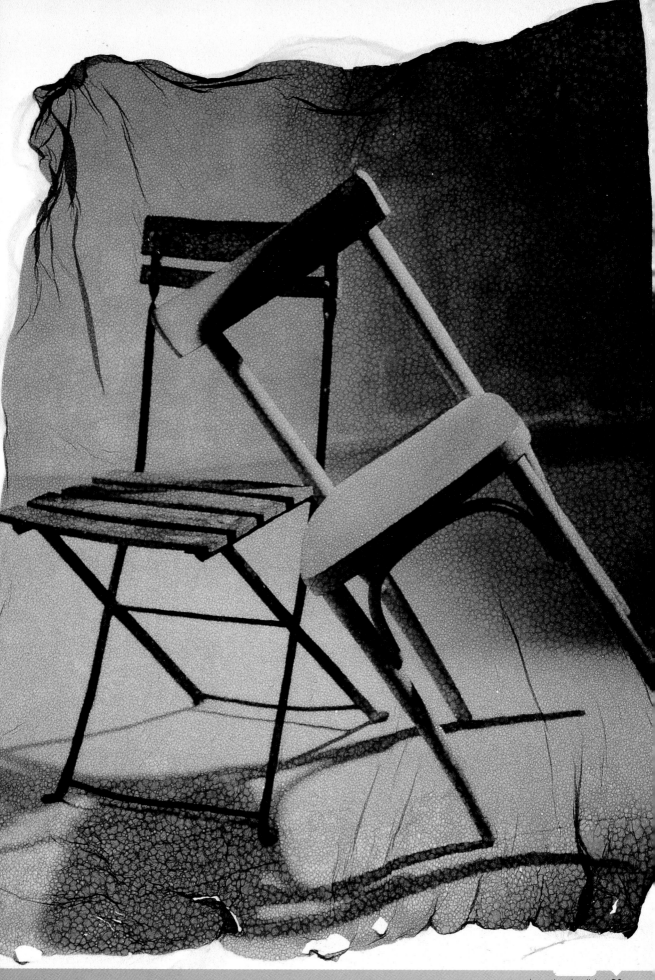

F Ü L L E R

▼

Photographer: **Rudi Mühlbauer**

Client: **Montblanc**

Use: **Catalogue**

Camera: **13x18cm**

Lens: **300mm**

Film: **Kodak Ektrachrome ISO 64/19**

Exposure: **f/22**

Lighting: **Electronic flash: two soft boxes**

Props and set: **Glass table, black velvet**

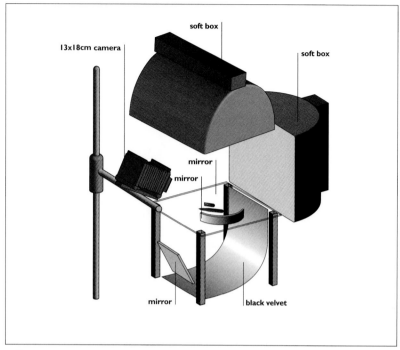

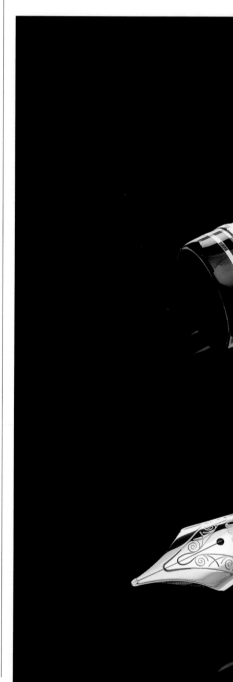

SHOOTING BLACK ON BLACK, WITH SPECULAR REFLECTIONS OF BOTH SILVER AND GOLD, IS A DEMANDING TEST OF THE PHOTOGRAPHER'S SKILL, THE SHARPNESS AND CONTRAST OF THE LENS, AND THE FILM.

The pen rests on a spotlessly clean glass table, lit from above with one 80 × 80cm (32 × 32in) soft box and from behind with another of the same size. A mirror under the table bounces light back up to fill the side of the pen nearest the camera, while a flexible plastic mirror to camera right creates modelling in the ends of the pen and cap. A third mirror, very small, is concealed behind the pen in order to brighten the clip on the cap. A black velvet curtain, draped under the table, takes care of the absolute blackness of the background.

In any picture like this, where the aim is to "see into the shadows", it is a good idea to use as large a format as possible. The larger ground-glass also makes it easier to see exactly where the highlights and shadows lie.

- ► Black on black and white on white are subjects which most photographers can profitably explore until they are proficient

- ► Pictures with bright metal and black on black are most easily tackled with lower-contrast film, and even then, exposure is very critical indeed

- ► Treat a picture as a boring catalogue shot, and it will be a boring catalogue shot. Treat it as a still life, and it will be one

Plan View

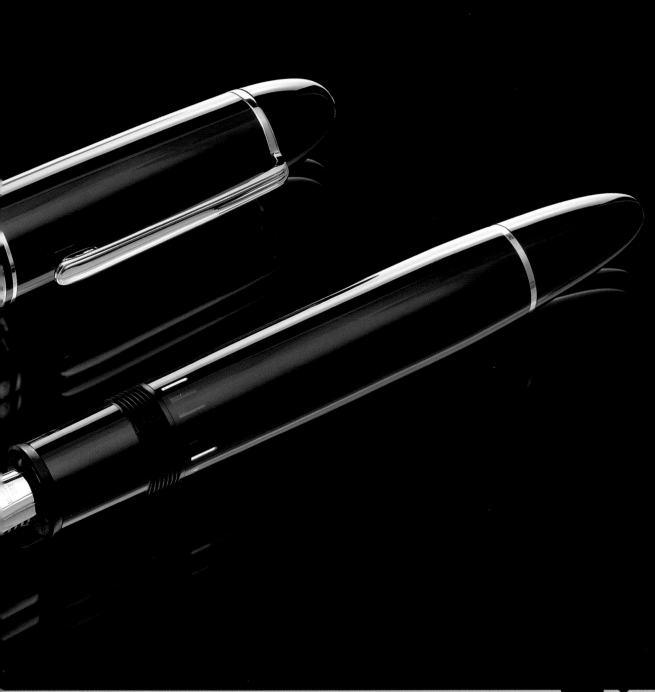

Photographer: **Marc Joye**

Client: **Broncolor**

Use: **Magazine**

Camera: **4x5in**

Lens: **90mm**

Film: **Kodak Ektachrome 64**

Exposure: **f/45**

Lighting: **Electronic flash: 1 head**

Props and set: **Paper models made by the photographer; painted background; "perspective" ground**

Plan View

► *Photographic quality can be independent of other aesthetic considerations, either complementing them or detracting from them*

► *The technique of double exposure to create "ghosting" is insufficiently explored by many photographers: it is (or can be) much more than merely a trick*

ILLUSTRATION

▼

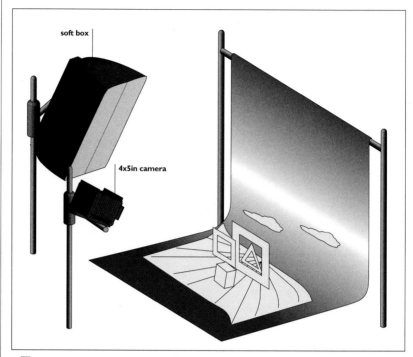

soft box

4x5in camera

THIS SURREAL "LANDSCAPE" DEMONSTRATES THAT THERE ARE AESTHETIC CONSIDERATIONS WHICH ARE NOT FULLY EXPLICABLE INTELLECTUALLY: THERE IS A DALI-ESQUE QUALITY TO THIS PICTURE, YET IT IS MORE FORMAL THAN MOST OF DALI'S WORK AND VERY PHOTOGRAPHIC IN ITS NATURE.

The paper sculptures rest either directly on the base or are raised very slightly above it on supports. The only light is an 80 × 80cm (32 × 32in) soft box to camera left, but the secret of the picture lies in the exposure being split in two. For the first exposure (one flash) everything was in place except the small windowed piece of paper to the left. For the second flash this piece of paper was added. The 90mm lens explains the perspective, and the only other factor to note is the very careful exposure control needed to retain tone and differentiation in the dark face of the cube. Any less exposure and it would have merged with the shadow. Any more exposure would have meant that the bright face was overlit and might have flared.

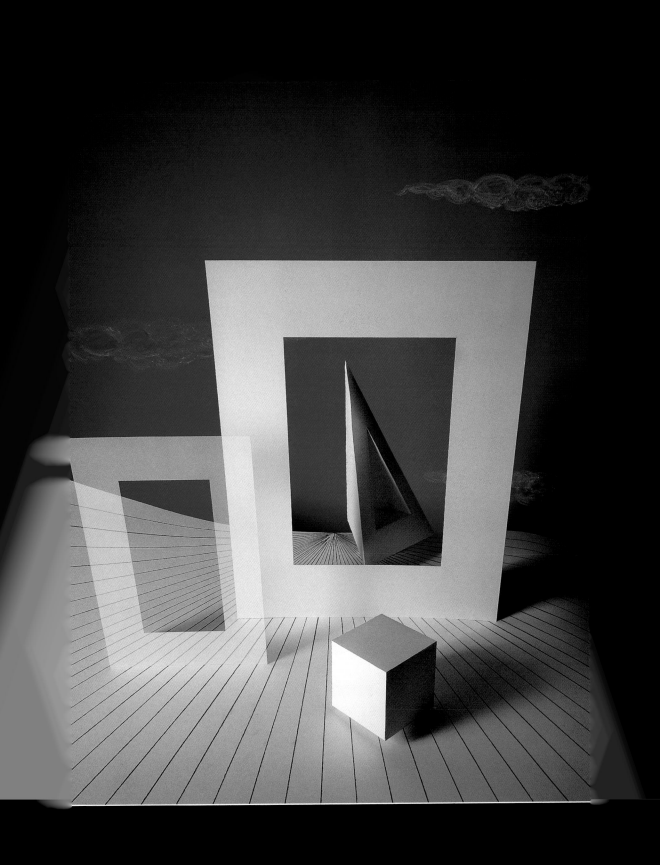

deceptive sim

CHANDELIER

▼

6x7cm camera

standard head
with reflector

tracing
paper

Photographer: **Mark Williams**

Client: *World of Interiors* **magazine**

Use: **Editorial**

Art director: **Barbora Hajek**

Camera: **6x7cm**

Lens: **180mm**

Film: **Fuji RDP ISO 100**

Exposure: **f/22**

Lighting: **Electronic flash: 1 head**

Props and set: **Chandelier parts; etched glass**

As Mark himself modestly says, "It wasn't particularly difficult to light, but I think we got a striking shot with a very simple set-up — it's a matter of layout and detail."

There is only one light shining through the subject. The chandelier components are resting on the shiny side of a piece of matte-etched glass, which acts as a diffuser in its own right, and there is a piece of tracing paper as further diffuser between this and the light – an Elinchrom 202 with an S2 head in a 45cm (18in) reflector. The camera is, of course, directly overhead. Both etched and polished glass can be very unforgiving media to work with, showing fingerprints mercilessly. Worse, although fingerprints are easy to clean off polished glass, they can be very hard to remove from etched or ground glass without smearing.

Photographer's comment:

World of Interiors *aims to show you how to achieve the effects you want, and what you need to help you achieve them.*

► Capturing the brilliance of cut glass is often best achieved by emphasizing the precision and clarity of the facetting

► Grading the image from the centre (instead of using a uniform light box) adds interest and allows dramatic contrasts of light and dark within the cut glass

Plan View

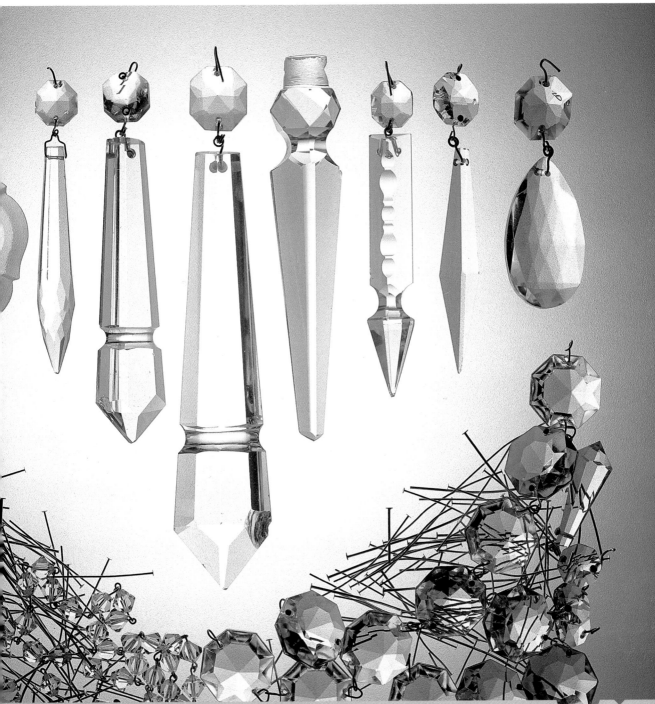

Photographer: **James DiVitale**

Use: **Self-promotion (Black Book)**

Designer: **Sandy DiVitale**

Camera: **4x5in**

Lens: **210mm (plus diffuser for first exposure)**

Film: **Kodak Ektachrome EPP ISO 100**

Exposure: **Double exposure: see text**

Lighting: **Electronic flash + light brush**

Props and set: **Backdrop by Rear Window
Productions**

Plan View

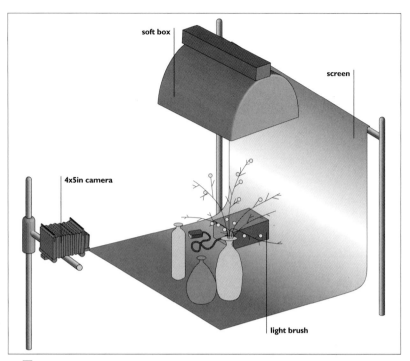

THIS HANGS IN THE STUDIO OF DIVITALE PHOTOGRAPHY, INC., AND IS THE FIRST THING PEOPLE SEE WHEN THEY COME IN. THEIR ALMOST INVARIABLE REACTION IS, "THAT LOOKS JUST LIKE A PAINTING."

There were two exposures, one using a soft box directly over the subject and the second using a Hosemaster light brush. The first was set slightly dark – f/32 – as exposure would inevitably build with the light brush. For this exposure, there was a heavy (#3) soft-focus screen over the lens.

The second light brush exposure took a total of three or four minutes and included painting highlights onto the subject as well as transilluminating the bottles. The soft-focus screen was removed for this exposure.

The bottles were of thick glass and required about 20 seconds for the orange one and about a minute for the blue one: they would have been very hard to transilluminate in any other way.

► *Most people think of light brushes for adding highlights – but they can also transilluminate*

► *Complete darkness is not necessary for light brushing, but low light levels are*

► *Gary Regester's "Tallat" shutter can be used to insert or remove filters and soft-focus screens during an exposure*

Photographer's comment:

This picture has done very well for us in promoting sales. It uses our "diffuse background – sharp highlights" technique.

Photographer: **James DiVitale**

Use: **Shot for self-promotion; put into stock; used by printing company**

Designer: **Sandy DiVitale**

Camera: **4x5in**

Lens: **210mm (plus diffuser for first exposure)**

Film: **Kodak Ektachrome EPP ISO 100**

Exposure: **Light-brush (see text)**

Lighting: **Electronic flash plus light brush**

Props and set: **Shell from Florida; earth from New Mexico**

Plan View

► *Light brushes are normally used in conjunction with other light sources*

► *Light brushes vary in power, and with some, working at very small apertures may involve inconveniently long exposures*

► *Streaks of light can be added with a light brush where there are no highlights, just to add interest*

C H A M B E R E D B E A U T Y

▼

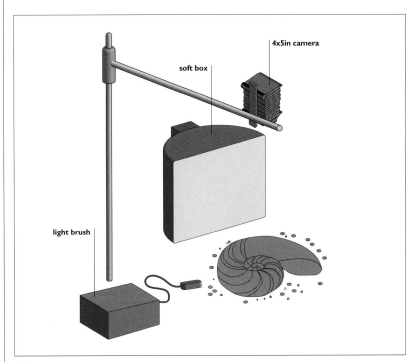

Lᴵᴷᴱ "Sᴘʀᴀʏ" ᴏᴘᴘᴏꜱɪᴛᴇ, ᴛʜɪꜱ ᴘɪᴄᴛᴜʀᴇ ᴜꜱᴇᴅ ᴇʟᴇᴄᴛʀᴏɴɪᴄ ꜰʟᴀꜱʜ ꜰᴏʀ ᴀ ᴅᴀʀᴋ, ʙᴀꜱᴇ ᴇxᴘᴏꜱᴜʀᴇ, ᴀɴᴅ ᴀ ʟɪɢʜᴛ-ʙʀᴜꜱʜ ᴛᴏ "ᴄᴏʟᴏᴜʀ ɪɴ" ᴛʜᴇ ꜱʜᴇʟʟ ᴀɴᴅ ᴀᴅᴅ ᴛʜᴇ ꜱᴛʀᴇᴀᴋꜱ ᴏɴ ᴛʜᴇ ᴇᴀʀᴛʜ. Tʜᴇ ᴛᴡᴏ ᴘɪᴄᴛᴜʀᴇꜱ ᴀʀᴇ ʜᴏᴡᴇᴠᴇʀ ᴠᴇʀʏ ᴅɪꜰꜰᴇʀᴇɴᴛ.

The base exposure, with a strong diffuser over the lens, was made with a soft box side-lighting the shell; this was at f/32, two stops down from the exposure needed to get a good image. The Hosemaster light brush was then used for a series of exposures from 5 to 15 seconds to light the shell, to transilluminate it, and to add the streaks of light on the background. The result is that the shell seems to glow with an unearthly beauty against a deeply coloured background. Only very rarely is a light brush used on its own to light a whole picture: normally, it is used in conjunction with flash or (more rarely) with continuous lighting to give a base exposure.

Photographer's comment:

We found this dirt in New Mexico and I brought back several bags of it. My luggage was so heavy it had to be hand-carried: the conveyor could not handle it. We were surprised that no-one asked us what was in it.

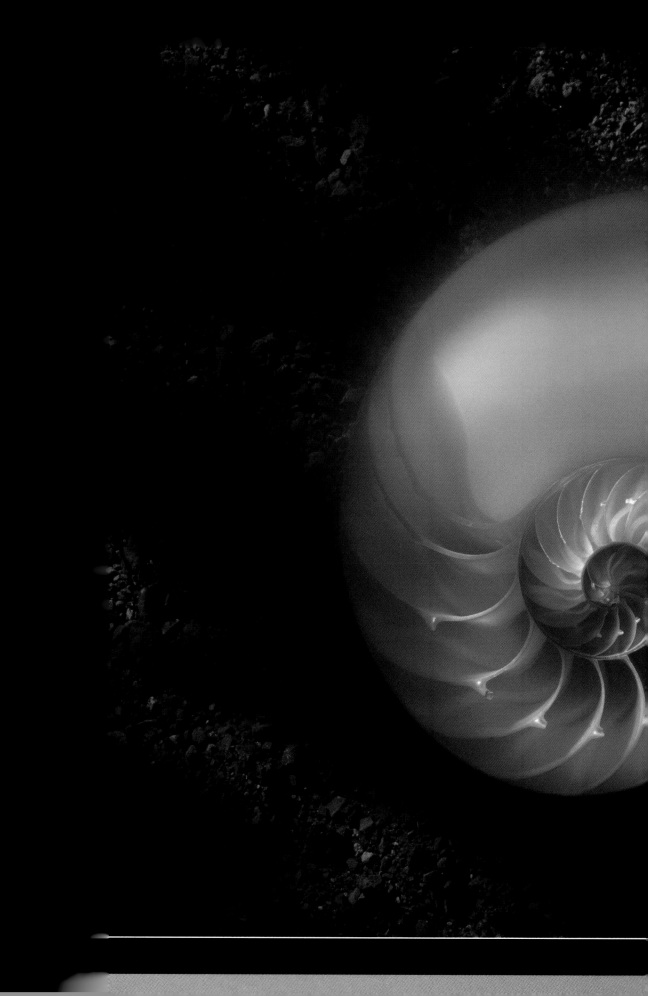

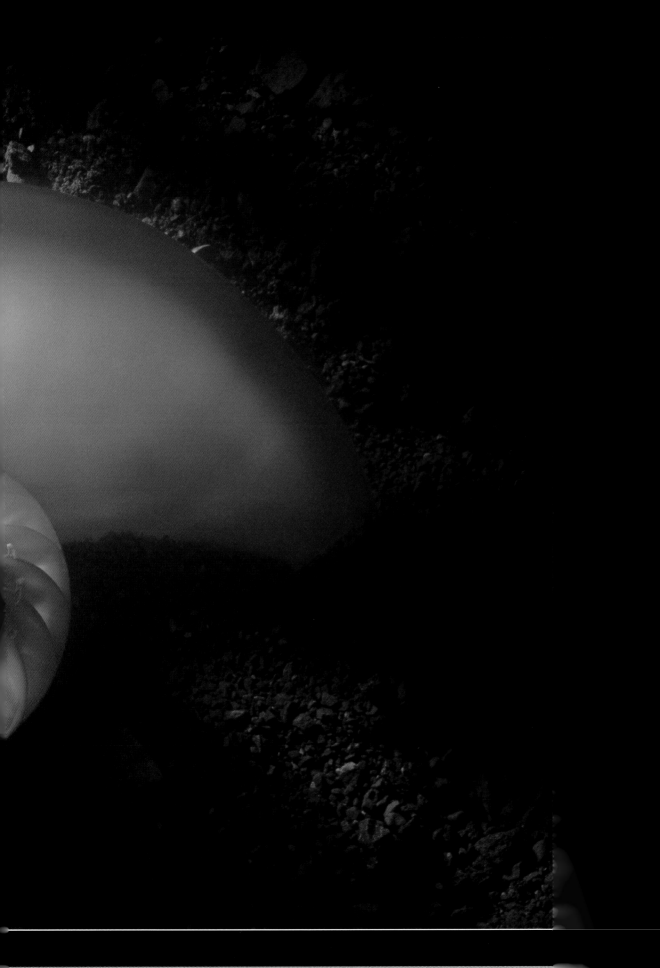

Photographer: **James DiVitale**

Client: **S. P. Richards company**

Use: **Corporate brochure**

Designer: **Sandy DiVitale**

Camera: **4x5in**

Lens: **210mm**

Film: **Kodak Ektachrome EPP ISO 100**

Exposure: **First: f/5.6; second: f/32½**

Lighting: **Electronic flash: 2 heads**

Props and set: **Fluorescent tubes, desk lamp**

Plan View

S I D E L I G H T

▼

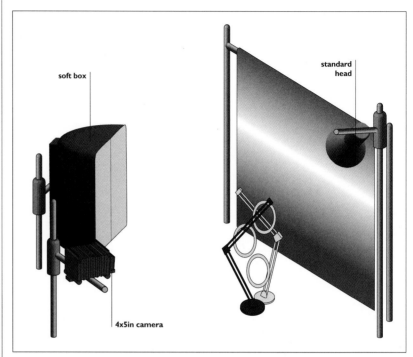

soft box

standard
head

4x5in camera

THIS USES THE "SPLIT-DIFFUSION" DOUBLE-EXPOSURE TECHNIQUE WHICH JIM DIVITALE HAS EXPLORED EXTENSIVELY. THE BACKGROUND AND FOREGROUND ARE LIT SEQUENTIALLY, THE FORMER WITH A DIFFUSER IN FRONT OF THE LENS, THE LATTER WITHOUT.

The background is 120–150cm (4–5ft) behind the principal subject and is lit with a standard head, high and to camera right; this casts a streak of light across the background. The first exposure, with this light only, was made with a heavy diffuser on the lens ("I probably cut up a plastic bag to make it") and with the lens at full aperture: the power to the light was turned right down. The main subject – three circular fluorescent tubes, and two angle-lamp brackets – is lit by a 30 x 60cm (12 x 24in) soft box to camera left and at about 45° to the line of sight: look at the highlights on the tubes. This shot was made without diffusion, and with considerably more power to the flash head.

► *"Press" or "everset" shutters, which do not need to be re-cocked between exposures, are useful for this sort of shot*

► *Even a seemingly unpromising subject can be turned into a good picture with skilled composition and lighting*

B O T T L E S O F W I N E

▼

Photographer: **Guido Paternò Castello**

Use: **Self-promotion**

Camera: **4x5in**

Lens: **210mm**

Film: **Kodak Ektachrome EPR ISO 64**

Exposure: **f/22**

Lighting: **Electronic flash: 1 soft box**

Props and set: **Black background**

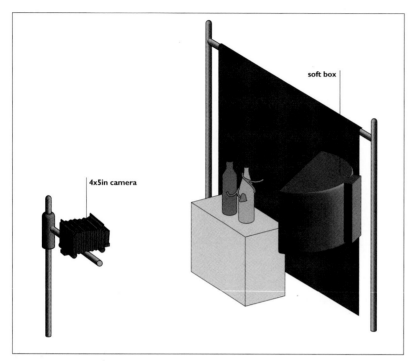

A SOFT BOX ON ITS OWN CAN BE VERY BORING; BUT COMBINE IT WITH A COUPLE OF BOTTLES WHICH REFRACT, REFLECT AND COLOUR THE LIGHT, AND YOU HAVE THE POTENTIAL FOR A MUCH MORE INTERESTING SHOT.

Compositionally the picture is remarkably subtle: the use of "negative space," the contrast of the regular man-made form of the bottles with the organic vine (and the implication of the man made/organic wine within), the drop of water on one vine tendril . . . The more you look at it, the more elegant this picture becomes. The light, however, is nothing more than a large soft box to camera right, which both side lights and back lights the wine. Although this looks very simple, there is often a need for considerable jockeying of the light's position in order to get the right width in the streaks of colour showing through the bottles. A plain black backdrop, well behind the bottles, allows them to stand out against absolute blackness.

▶ Often, the simpler a picture is, the more effort you have to make in order to get it exactly right

▶ If the bottles had labels on them, this would be a boring advertising shot; but this is a picture of Wine, not of any individual wine

Plan View

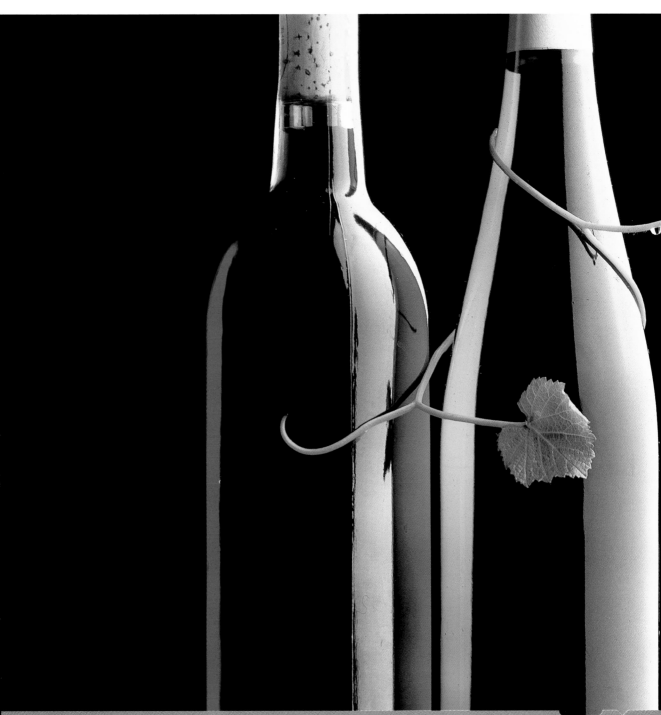

KEY MOUSE

▼

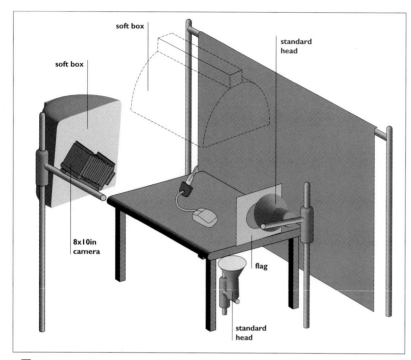

Photographer: **Jay Myrdal**

Client: **SPC Software**

Agency: **Kline Grey**

Use: **Press and trade advertising**

Art director: **Vic Hazeldine**

Camera: **8x10in**

Lens: **300mm**

Film: **Fuji Velvia rated EI 32**

Exposure: **f/64; double exposure, three "hits" each**

Lighting: **Electronic flash: 3 heads**

Props and set: **Oversize key made by Parallax**

THE "DECEPTIVE SIMPLICITY" IN THIS SHOT IS THAT THE LIGHTING WAS FAR MORE DIFFICULT THAN IT SHOULD HAVE BEEN. THE ANSWER WAS TO MAKE ONE EXPOSURE FOR THE RING AND ANOTHER FOR THE KEY AND MOUSE.

The first exposure was made with the overhead soft box alone, very close to the subject. Everything except the ring was masked off. A circle of velvet sat inside the ring; more velvet was used to mask the rest of the background, the key and the mouse; and the edges of the picture were flagged off at the camera rather than at the subject.

For the second exposure the soft box was raised up out of the way and the masks were removed. A small soft box to camera left lit the key; a standard head, heavily flagged, was set very low to provide a glancing light and a long shadow on the mouse; and a standard head below the set transilluminated the background.

Photographer's comment:

I shot this on both Kodak Ektachrome 64 and Fuji Velvia — I like Velvia for the greens.

► *Precision masking with velvet may be tiresome, but it can be very useful*

► *Where precision is not needed, flagging at the camera lens is quicker and easier*

► *Seemingly simple shots can be surprisingly demanding when it comes to lighting*

Plan View

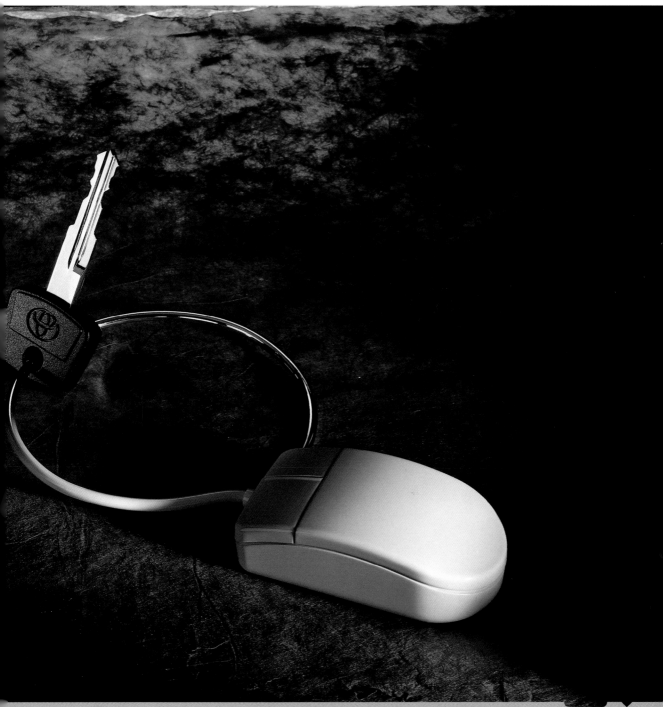

3

found images and
abstractions

In some ways, these are the "purest" still lifes in this book: they are things which stand alone, not particularly as a symbol of anything, but as representations of themselves alone – even if it is not immediately obvious what is represented. A semiotician could have a field day with these images, which are for the most part neither signs nor symbols but which can at least in some cases be taken as archetypes.

Almost half the 35mm images in the book are to be found here, as well as one of the only two black and whites. They are somewhat outside the main stream, it is true, but then, so were Weston's peppers or the geometrical compositions which flourished between the two World Wars.

In the Introduction to this book we remarked on our surprise at getting no traditional still lifes with dead pheasants and Rembrandt lighting. Once again, we were surprised in this chapter not to receive more extreme close-ups and studies of line, texture and form; but, again, this may indicate present fashions. Certainly the most luxurious representations of texture and form to be seen in fine-art photography today are mainly of plant life, often captured on 8 x 10in – a reaction, perhaps, against the glorification of the man-made, which began so dramatically with the Vorticists and which was developed with equal panache in Lenin's Russia and Weimar Germany.

We felt, though, that pictures of living plants were outside our brief: we would no longer be dealing with *nature morte* (a term which rings somewhat chillingly in non-French ears) but with a branch of landscape photography.

Photographer: **Marc Joye**

Client: **Printing Office Roels**

Use: **Calendar**

Camera: **4x5in**

Lens: **150mm**

Film: **Kodak Ektachrome 4 x 5in**

Exposure: **f/45**

Lighting: **Electronic flash: 3 heads**

Props and set: **Built set**

Plan View

► *The camera can distort scale and conflate built sets with naturalistic photographs*

► *Polaroid tests are often the easiest way to confirm the balance of "indoor" and "outdoor" lighting*

► *Some photographers keep libraries of pictures to be combined, either by traditional photographic means (as here) or electronically*

CALENDAR IMAGE

▼

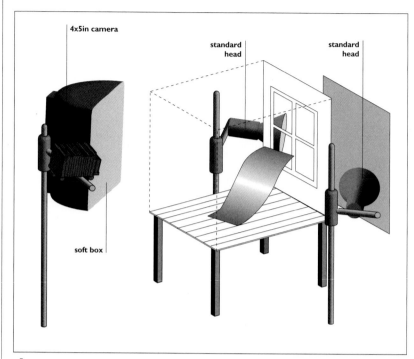

4x5in camera

standard head

standard head

soft box

Lɪᴋᴇ ᴍᴀɴʏ ᴏꜰ Mᴀʀᴄ Jᴏʏᴇ's ᴘɪᴄᴛᴜʀᴇꜱ ᴛʜɪꜱ ᴏɴᴇ ʀᴇʟɪᴇꜱ ᴏɴ ᴍᴜʟᴛɪᴘʟᴇ ᴇxᴘᴏꜱᴜʀᴇ ᴀɴᴅ ᴀ ʙᴜɪʟᴛ ꜱᴇᴛ. Wɪᴛʜ ᴍᴜʟᴛɪᴘʟᴇ ᴇxᴘᴏꜱᴜʀᴇꜱ ɪᴛ ɪꜱ ᴘᴀʀᴛɪᴄᴜʟᴀʀʟʏ ɪᴍᴘᴏʀᴛᴀɴᴛ ᴛᴏ ᴍᴀɪɴᴛᴀɪɴ ᴄᴏɴꜱɪꜱᴛᴇɴᴛ ʟɪɢʜᴛɪɴɢ, ᴏʀ ᴛᴏ ᴜꜱᴇ ʟɪɢʜᴛɪɴɢ ᴡʜɪᴄʜ ɪꜱ "ɴᴇᴜᴛʀᴀʟ", ᴡɪᴛʜᴏᴜᴛ ɪɴᴄᴏɴꜱɪꜱᴛᴇɴᴄɪᴇꜱ ᴏꜰ ᴅɪʀᴇᴄᴛɪᴏɴ.

The basic set is the small, built "room" with the sheet of paper supported on a rod which passes through the back of the room and is concealed from the camera by the paper. This whole set is lit by a soft box 1m (39in) square.

Through the window there is a poster of a forest scene which is lit by two standard heads. Needless to say, the lighting of the poster and the room need to be carefully balanced, and this can be difficult to judge by eye or even by metering: Polaroid tests are the best route here.

The three pigeons – actually, three exposures of the same pigeon, slightly enlarged each time – were then exposed sequentially onto the same piece of film: they had previously been printed onto lith film to give a bright, contrasty image.

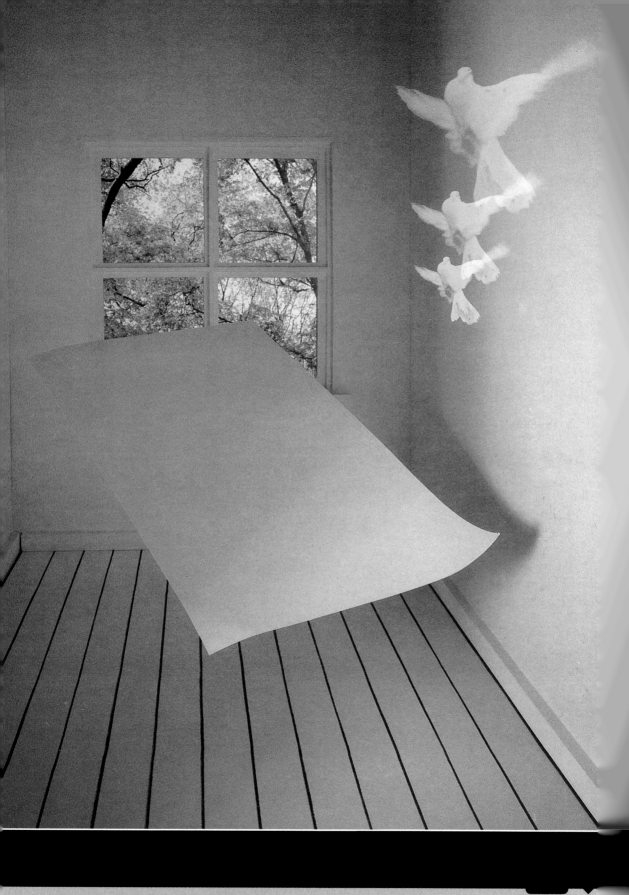

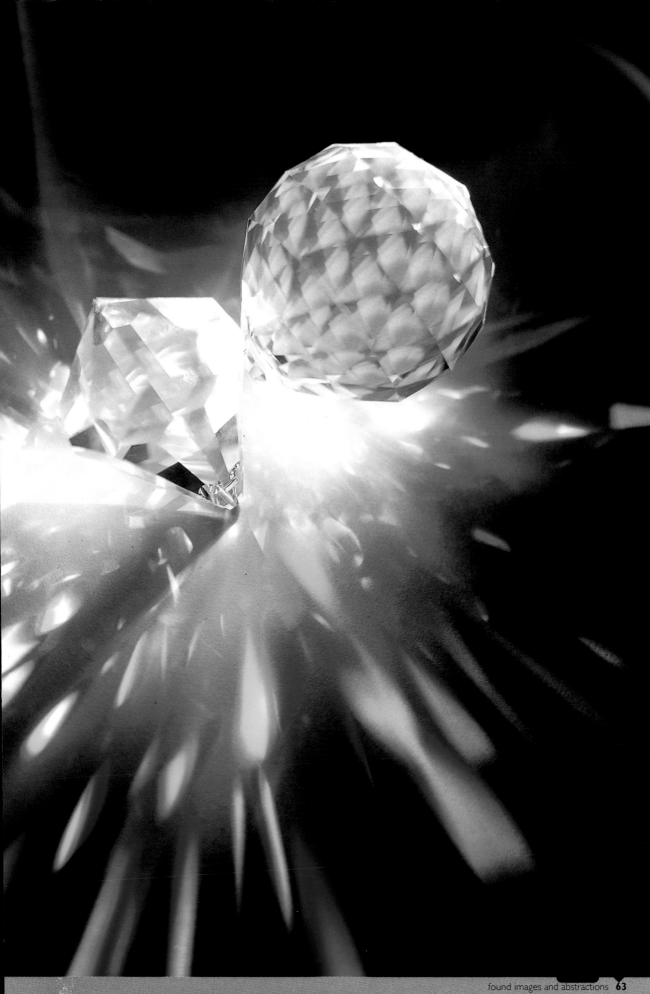

Photographer: **Raymond Tan**

Client: **Words Worth Media Management Pte Ltd**

Use: **Corporate brochure front cover**

Assistant: **Faizal**

Art director: **Shirley**

Camera: **6x7cm**

Lens: **250mm with extension tube**

Film: **Fuji Velvia RVP ISO 50**

Exposure: **15sec at f/5.6**

Lighting: **Light brush**

Props and set: **2 pieces clear crystal on white foreground**

Plan View

CRYSTAL BEAMS

▼

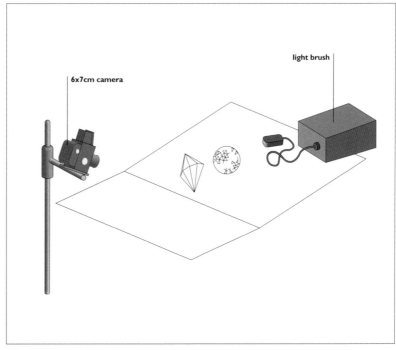

6x7cm camera

light brush

THE PHOTOGRAPHER EXPLAINS THE TECHNIQUE VERY WELL: "AS NORMAL LIGHTING WILL 'KILL' THE CRYSTAL BEAMS – THE WHOLE FOREGROUND WOULD BE LIT – A 15-SECOND EXPOSURE FROM A LIGHT-PAINTING SET IS USED TO ACHIEVE THE DESIRED EFFECT."

► *Beams of light are hard to capture because they are easily swamped by general illumination*

► *"Sparkle" and "fire" are very difficult indeed to capture because they are normally most obvious when the eye moves slightly relative to the facetted stone or crystal*

► *Precise focus is by no means essential when photographing a projected spectrum*

A white foreground is essential to capture the beams of light from the crystal, but where there are no beams absolute blackness is equally essential. It might be possible to achieve a similar effect by using some other form of light pipe, such as one of the macro lighting systems available from a number of manufacturers (Marco in Moscow, Novoflex in Germany, etc), but the light brush is a more familiar tool to most

photographers. To achieve this effect it was set for a "small telescope" beam.

The relatively wide aperture of f/5.6 is all that is needed: as long as the two pieces of crystal are in focus, a modest amount of loss of focus on the light beams is not important. Because the results are not totally predictable, it would be wise to shoot several versions and to select the best.

Photographer: **Kazuo Kawai**

Client: **Toyo Roshi**

Use: **Calendar**

Camera: **4x5in**

Lens: **210mm**

Film: **Kodak Ektachrome EPY**

Exposure: **1 sec at f/22**

Lighting: **Tungsten: 2 heads**

Props and set: **Stainless steel; ball-bearings; grey paper**

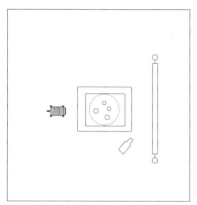

Plan View

MYSTERIOUS BALL

▼

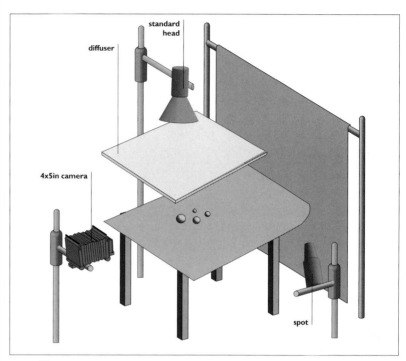

THIS IS FROM THE SAME SERIES AS THE OTHER KAZUO KAWAI SHOT ON PAGE 69 — AND, LIKE THE OTHER SHOT, IT IS A SIMPLE IDEA SUPERBLY EXECUTED. JUST KEEPING FINGERPRINTS OFF SUCH A SET-UP IS FAR FROM EASY.

The four ball-bearings are on a sheet of coloured stainless steel, which is curved up towards the back. A diffused 500W lamp casts a very even light, which is not reflected from the stainless steel: that reflects the dark background, which is partially lit by a 500W spot light. This all sounds very easy, and in a sense it is; but the secret of the success of the shot lies in very precise positioning of the balls, the steel sheet, the diffuser, the background and, of course, the lights.

► *Highly reflective mirror-bright surfaces will not be illuminated by what is above them: they will reflect only what is behind them, relative to the camera viewpoint*

► *Stopping ball-bearings rolling about on a stainless steel sheet is not easy*

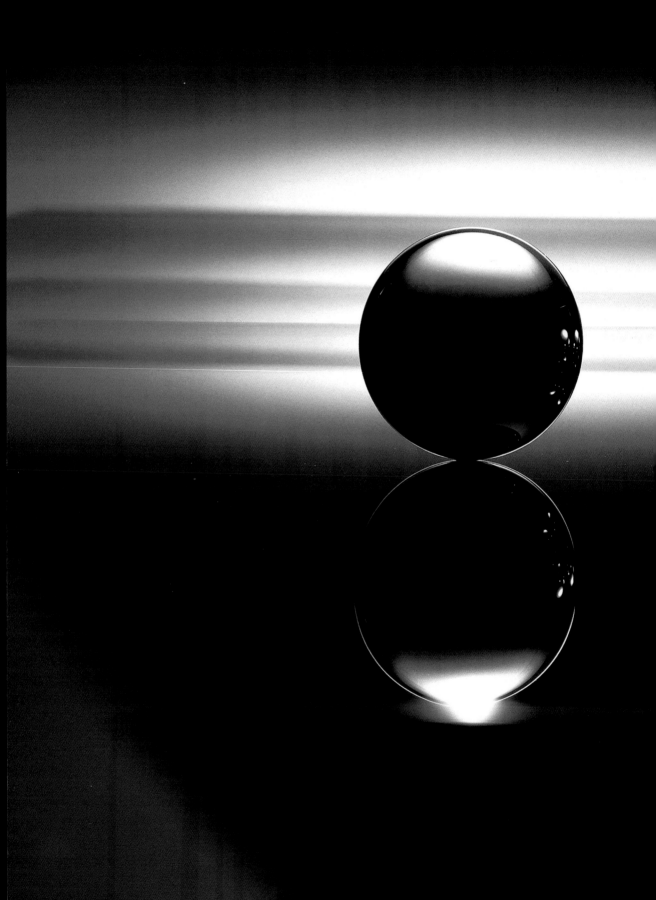

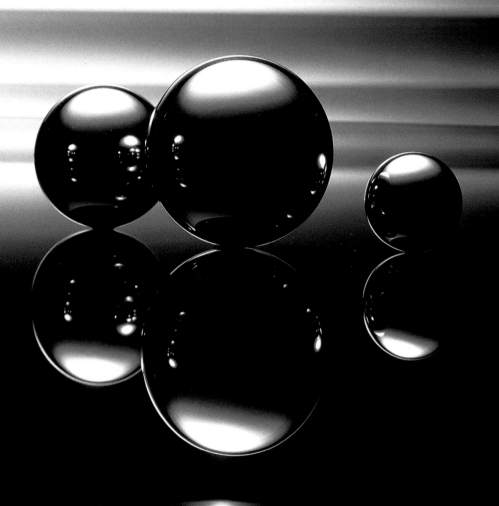

Photographer: **Kazuo Kawai**

Client: **Toyo Roshi**

Use: **Calendar**

Art director: **Koji Kojima**

Camera: **4x5in**

Lens: **180mm**

Film: **Kodak Ektachrome EPY ISO 64/19**

Exposure: **1sec at f/22**

Lighting: **Tungsten floods (two)**

Props and set: **Chromium plated steel**

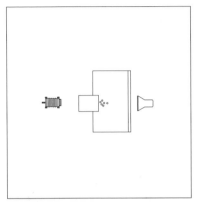

Plan View

► *To get good definition on water droplets you normally need a combination of strong highlights and strong shadows. This can be achieved with highly directional lighting, or with diffuse lighting and skillfully used black and white bounces*

► *Whenever you see something unexpectedly beautiful, ask yourself, first, how you would photograph it as it stands and, second, how you could re-create it in the studio*

► *Never assume that complex equipment is required to create a picture which you have in your mind's eye: instead, try to work out the simplest way to shoot it*

W A T E R B E A D S

▼

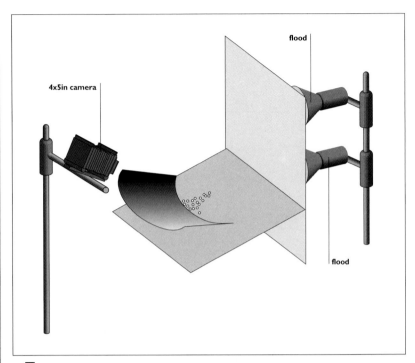

THIS IS AN IMAGE WHICH FAIRLY SCREAMS "HIGH TECHNOLOGY" AND IMPLIES COMPUTER MANIPULATION, ELABORATE SETS AND COMPLICATED LIGHTING. NOTHING COULD BE FURTHER FROM THE TRUTH. IT IS A STUNNINGLY SIMPLE PICTURE, BEAUTIFULLY EXECUTED.

The water droplets in the upper part of the picture are on a piece of thin, chrome-plated steel, like an old-fashioned glazing (ferrotype) sheet. A second, similar piece of steel is flexed nearer the camera, and reflects the droplets on the first piece. The lighting is nothing more than two photoflood bulbs, one 500W and the other 300W, behind a sheet of diffusing material: the whole set is back lit. Of course, getting the droplets where

you want them is not easy. Nor is finding precisely the right composition. Nor is exactly the right exposure. But this picture illustrates unusually clearly that vision is what photography is about. From a purely technical viewpoint this shot is well within the reach of any competent amateur. From an artistic viewpoint, and from the brilliant simplicity of its realization, it is far, far beyond mere competence.

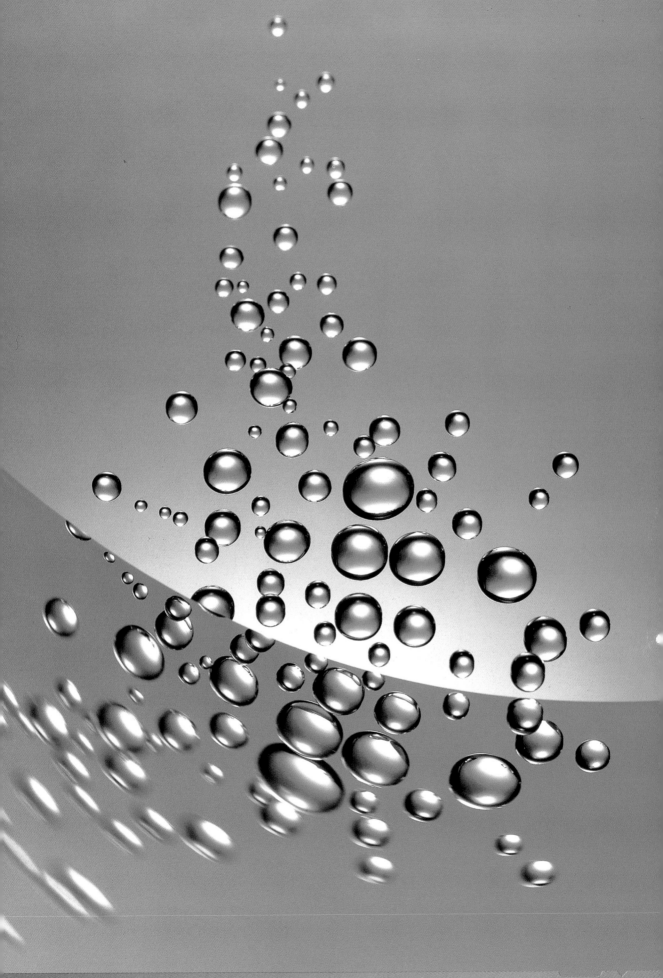

HOOD ORNAMENT

▼

Photographer: **Roger Hicks**

Use: **Editorial**

Camera: **35mm**

Lens: **90mm**

Film: **Kodachrome 64**

Exposure: **1/125sec at f/5.6**

Lighting: **Overcast daylight**

Props and set: **Location; Pontiac hood ornament**

Is THIS A STILL LIFE? IF NOT, WHAT IS IT? STRICTLY, IT IS NOTHING MORE OR LESS THAN A DETAIL FROM THE ORNAMENT ON THE HOOD (BONNET) OF A CAR; ONLY THE PHOTOGRAPHER'S EYE SEPARATES IT FROM A SNAPSHOT.

The lighting was a hazy-but-sunny day in Kentucky; the occasion was a vintage car meet. As is usual on such occasions, it was next to impossible to get good photographs of the cars as a whole because they were too close together, surrounded with people and adorned with placards giving their history and specifications. The only real possibility was to shoot details, which are for the most part clichés: the huge wheel filling the frame is a staple of magazines and reports. This old-fashioned Pontiac ornament is however unusual, handsome, and very clearly a part of an automobile.

It was shot for an article to demonstrate film latitude and the ways in which slight over- and under-exposure can enhance mood, but it has since appeared in a couple of books on photography and in one on graphic art.

Photographer's comment:

I shot this with a Leica rangefinder camera – not the best tool for close-ups, but it was what I had with me.

► *Often, the only way to get good detail shots is to shoot plenty of film*

► *Incident-light metering makes exposure easy: a through-lens reading would have meant that the subject was too dark*

Plan View

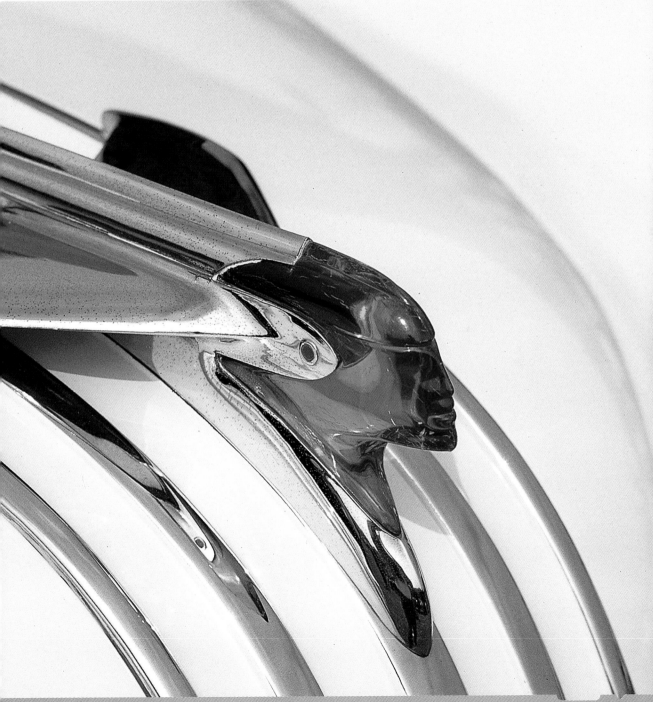

Photographer: **Frances E. Schultz**

Client: ***Shutterbug** magazine*

Use: **Editorial**

Camera: **35mm**

Lens: **90mm**

Film: **Ilford HP5 Plus**

Exposure: **1/500sec at f/8**

Lighting: **Daylight**

Props and set: **Greenwich Village, New York**

Plan View

B O O T S

▼

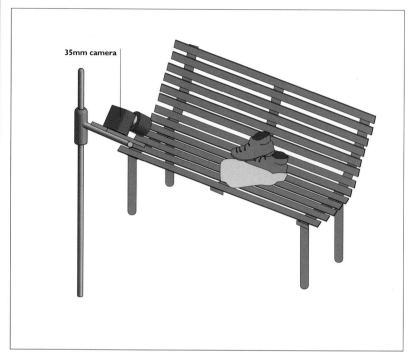

"I WAS IN NEW YORK FOR VISCOMM, THE PHOTO SHOW, AND (AS USUAL) I TRIED TO GET SOME PICTURES FOR SUBSEQUENT USE IN *SHUTTERBUG* MAGAZINE. I HAD NO PRECONCEPTIONS — I WAS JUST LOOKING FOR GOOD PICTURES."

This was shot at about two o'clock on a surprisingly warm and sunny day in late October; there was enough haze in the air to diffuse the contrast of the light somewhat. The boots are entirely "as found"; they were not re-arranged by the photographer. The bag (again "as found") acted as a bounce to provide fill on the lower boot.

The attraction clearly lies in the variety of textures, and this proved to be one of those negatives which bears out the truth of Ansel Adam's celebrated dictum that the negative is the score and the print is the performance: it can be interpreted in a number of ways, with more or less radical burning and dodging, and with or without toning.

► *The exhortation to carry a camera at all times may pay better dividends to the still life photographer than to anyone hoping for a news "scoop"*

► *A light tripod can greatly enhance the sharpness of pictures*

► *Lenses with closer-than-normal focusing ability are often very useful to those who shoot still lifes on 35mm*

Photographer's comment:

I find it best to work with another photographer or an assistant on the streets of New York. We can watch one another's backs when we are shooting.

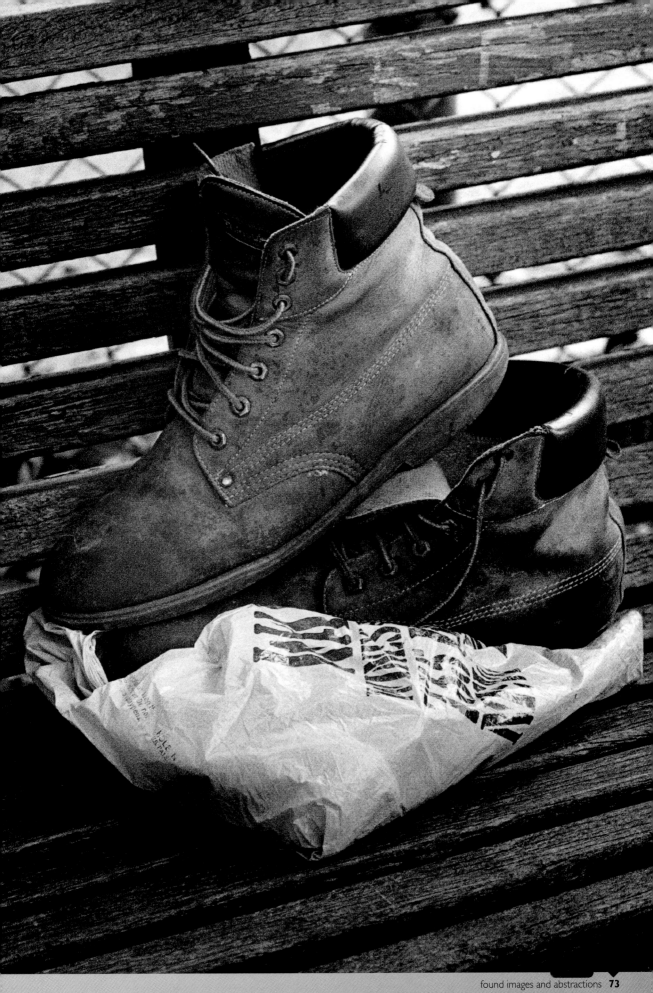

Photographer: **Roger W. Hicks**

Use: **Editorial**

Camera: **35mm**

Lens: **70–210mm zoom**

Film: **Fuji RDP ISO 100**

Exposure: **Not recorded: probably 1sec at f/8**

Lighting: **Sunlight, firelight**

Props and set: **Location: Auberge St.-Hubert**

Plan View

FIREPLACE, BURGUNDY

▼

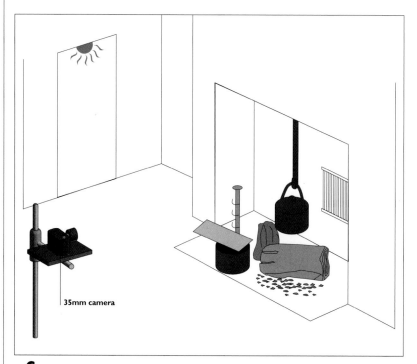

35mm camera

Constructing still lifes in the studio can be fun, but it is also a great pleasure when you run across them — when they are just "found" — as are several of the images in this chapter.

"We noticed this fireplace on the night we arrived, and I vowed to take a picture of it the next morning, when daylight would provide some fill. The weather the next day was unsettled: shafts of weak sunlight would shine through the window to the left of the fireplace for a few seconds, and then disappear for minutes on end. Also I wasn't sure just how much to increase the exposure in order to capture the black-on-black without losing the lighter parts of the image altogether – though, as can be seen, parts of the soot were surprisingly reflective. What I eventually did was to bracket furiously, ranging from the value indicated by an incident light reading to three or four stops over. A range of exposures was acceptable, but this is the one I like most."

► *There is a considerable difference between internal contrast – the ability of a lens to separate tones – and film contrast*

► *Fujichrome 100 was able to hold the tonal range in this picture: Velvia, from the same manufacturer, might not have*

Photographer's comment:

We were on our way back from a shoot in Italy, where we had been involved in an accident within an hour of arriving. We spent a few days in Burgundy to recuperate.

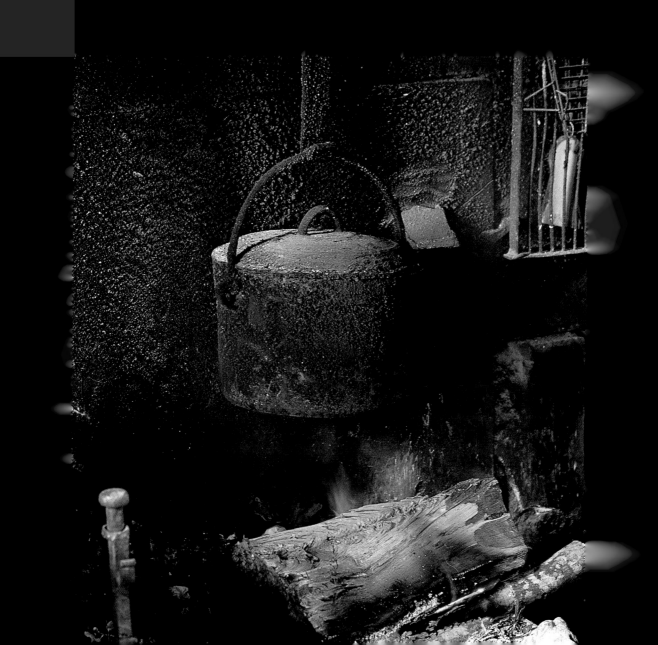

4

form, colour and
texture

In one sense the previous chapter was concerned with form, colour and texture; but the difference between the pictures on the last few pages and the ones in this chapter is that these are much more representational. In most of the pictures grouped under this heading the photographer is showing us something as if for the first time: he or she is making us more aware of something which we might not have noticed in the ordinary course of things, and reminding us of its qualities. In other words, it is the thing itself which is being shown to us, as a teapot, or an ear of corn, or even a stack of paper, and our attention is being drawn to its form, colour or texture.

This is not all that is here, though. In particular, Maurizio Polverelli's Aries, the Ram uses form, colour and texture as a symbol rather than as a representation, and his Gemini is arguably both symbol and sign – the latter, of course, in both the semiotic sense and in the joky double-meaning sense which is so beloved of (for example) Umberto Eco.

But such talks of semiotics reveals, all too clearly, that while photography is a multi-layered undertaking where even the most abstruse concepts may be brought into play, its feet remain firmly on the ground even as its practitioners reach for the sky: essentially, the pictures here show us how to transfer an idea onto film, leaving the idea to speak for itself through the image. We can all understand the beauty or impact of a picture, whether or not we dig for deeper meanings.

Photographer: **Johnny Boylan**

Client: **S.M.I./Powergen**

Use: **Advertising**

Assistant: **Annie Howard Phillips**

Art director: **Roy Brooks**

Camera: **4x5in**

Lens: **210mm**

Film: **Kodak Ektachrome EPR**

Exposure: **f/11½**

Lighting: **Flash: 1 head**

Plan View

C O R N

▼

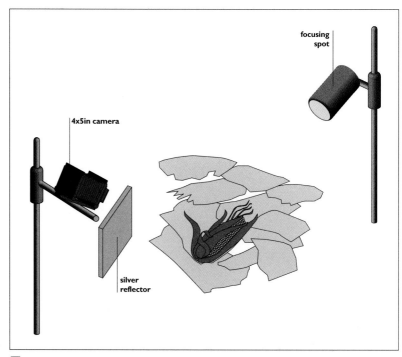

THE LIGHTING HERE IS DECEPTIVE. CLEARLY IT IS VERY HARD AND CONTRASTY, BUT EQUALLY IT IS QUITE BROAD: IT IS NOT A CONVENTIONAL SMALL FOCUSING SPOT. ALSO THERE IS SOME SLIGHT FILL FROM THE LEFT AND ON THE STEM END OF THE COB.

The secret is a big, old 2K focusing spot which the photographer adapted to take a flash head. The beam is tight, in the sense that the sides are close to parallel, but it is also quite a large light source. "Quality of light" is one of those terms which is easier to recognize than to analyze, but obviously the quality here is different from a small focusing spot, a large reflector, or of course a soft box.

There is also a small silver reflector to camera left to throw some light back onto the end of the cob, which would otherwise be dark and without roundness. This throws a little light into the shadows on the left, still further emphasizing their texture.

► *Quality of light is a question of source size, directionality and diffusion*

► *Hard lighting reveals fine detail and texture*

► *Camera movements allow a receding plane to be held in focus without stopping down (the Scheimpflug rule)*

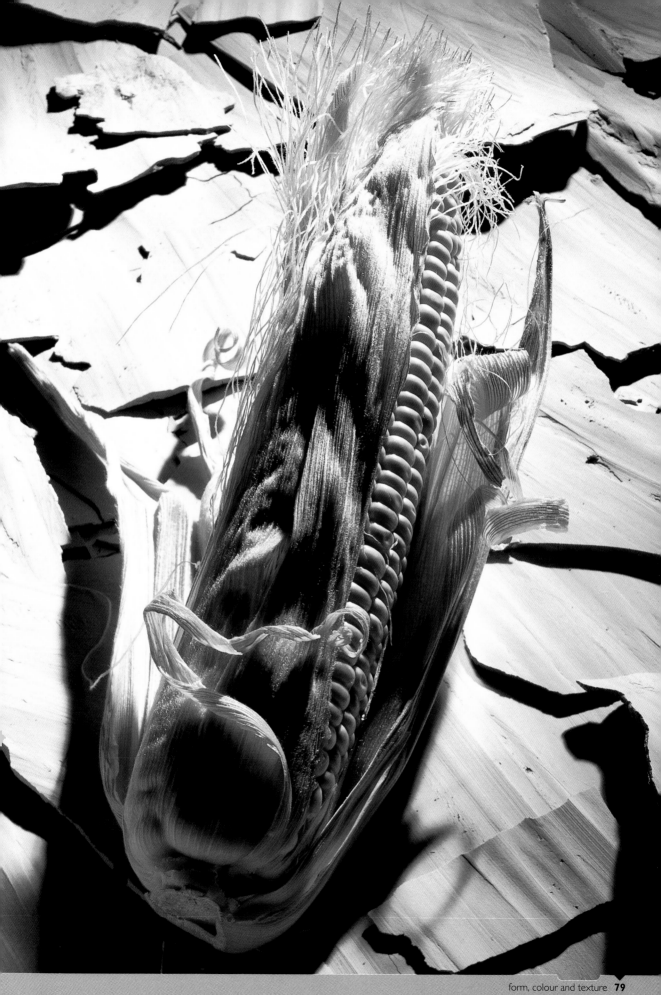

Photographer: **Frances E. Schultz**

Client: **David & Charles**

Use: **Editorial (*The Film Book*, 1994)**

Camera: **35mm**

Lens: **35mm**

Film: **Ilford XP-2**

Exposure: **1/500sec at f/8½**

Lighting: **Sunlight, close to noon**

Props and set: **Collapsible walking stick**

Plan View

S T I C K A N D W A L L

▼

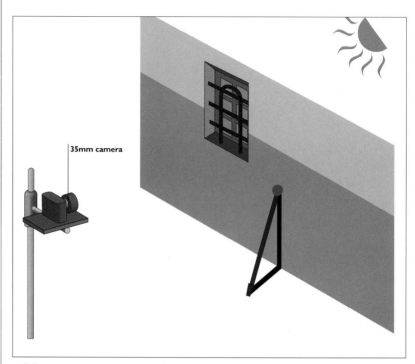

35mm camera

Most photographers set up a picture and then light it. Here, Frances Schultz saw the lighting and set up the picture, adding the walking stick to balance the composition and emphasize the shadows.

The tonal range of the image is enormous, from specular reflection of sunlight on the brass head of the cane to pitch darkness through a broken pane in the window. As can be seen, the sun was almost directly overhead – this was around noon in April at Aosta, in the Italian Alps – and the light is very contrasty. The picture was made to illustrate the range of tones which can be recorded with a black and white film, especially with XP-2. Devotees of the Zone System will be able to find every single zone in this picture. The same picture, shot in colour as a reference, is very different.

► *Sometimes, a particular kind of light cries out to be used*

► *Shadows move surprisingly quickly, so you have to work fast when shooting in bright sun*

► *Ilford XP2 captures a wider tonal range than any other monochrome film on the market*

Photographer's comment:

What attracted me to this picture was the grey patch which runs diagonally across the top right, and the shadow on the lower left. I added the stick to balance the composition.

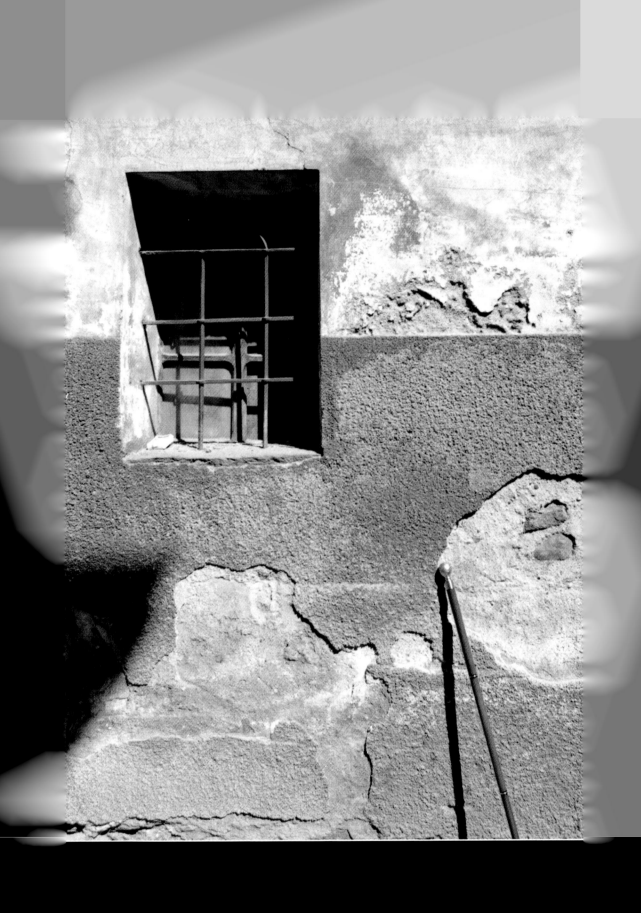

form, colour and te

Photographer: **Mark Williams**

Client: **RSCG Conran Design**

Use: **Point-of-sale advertising**

Art director: **Emma Hall**

Camera: **4x5in**

Lens: **75mm**

Film: **Fuji Velvia**

Exposure: **f/32**

Lighting: **Electronic flash: five heads**

Props and set: **S-curve light table**

Plan View

P O U R I N G O L I V E O I L

▼

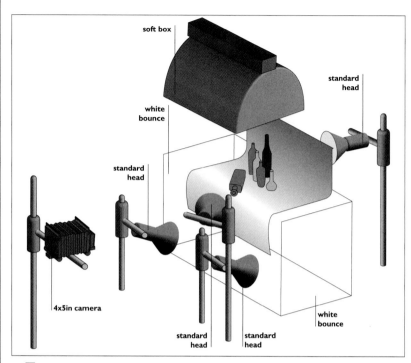

"**T**HIS WAS ONE OF THOSE REALLY ENJOYABLE JOBS WHERE THE ART DIRECTOR HAD A FREE HAND AND I COULD CREATE A PICTURE TO BE PROUD OF, RATHER THAN JUST WORKING OUT HOW TO MEET A BRIEF."

This is one of Mark's favourite pictures, and it is easy to see why. All the bottles are on a Perspex (Lucite) shooting table, the sort which has an up-curve at the back and a down-curve at the front. There were white bounces on either side and at the back, and a 1m (39in) square soft box overhead. Two 1500-Joule heads were bounced down onto a sheet of white paper on the floor under the table to create a very soft, even light, and another head shone through the up-sweep at the back of the table. The fifth light was a standard head with a spill kill, mounted just to camera right to create highlights.

► *Mark shot 20 sheets of film, choosing the one where the oil looked best. The bottle had to be refilled for each shot*

► *Extensive movements are often necessary in shots like this to control both perspective and sharpness*

Photographer's comment:

We pulled the movements all over the place in order to get the perspective right and the bottles in the back group upright.

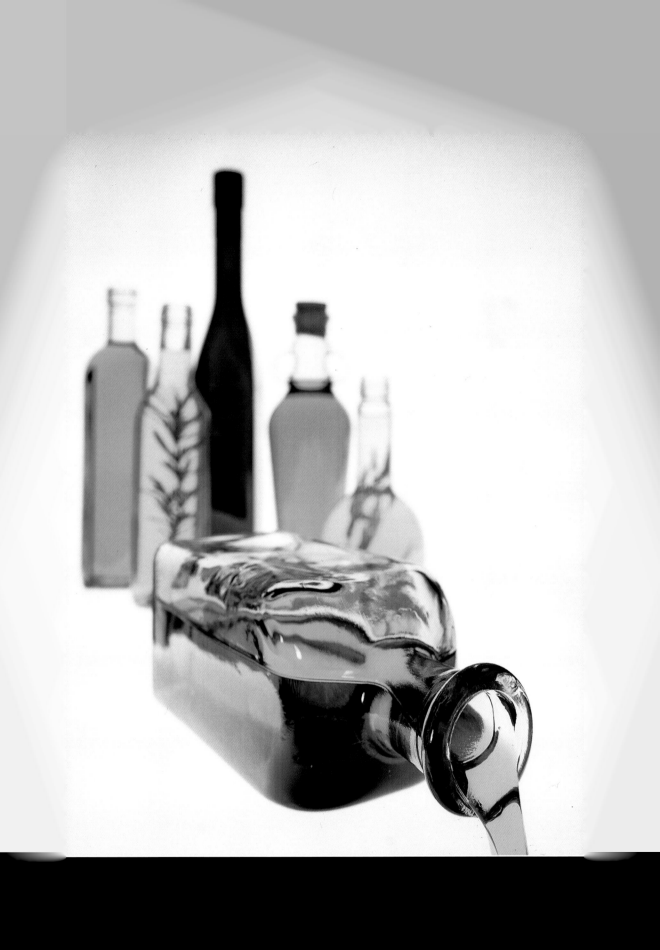

form, colour and te

Photographer: **James DiVitale**

Use: **Shot for self-promotion; put into stock; used by printing company**

Designer: **Sandy DiVitale**

Camera: **4x5in**

Lens: **210mm**

Film: **Kodak Ektachrome EPP ISO 100**

Exposure: **f/45**

Lighting: **Electronic flash: one head**

Props and set: **Black felt background**

Plan View

T E A P O T

▼

SOMETHING LIKE THIS TEAPOT WOULD INSPIRE MANY PHOTOGRAPHERS: A COMBINATION OF FORM, COLOUR AND TEXTURE WHICH JUST BEGS TO BE PHOTOGRAPHED. IT WOULD BE INTERESTING TO SEE HOW (SAY) SIX DIFFERENT PHOTOGRAPHERS TACKLED IT.

If you examine the highlights closely you can pretty much see what sort of light was used on the teapot. It was a frame about 30cm (12in) square with a single standard head behind it – nothing very complicated. This is an important lesson. Although it is useful to be able to draw on a full range of lighting equipment, there are times when all that is needed is very simple indeed. The "steam" is actually a small white smudge on the background, well out of focus, lit by spill, which reads as a puff of steam: a classic example of using people's expectations to persuade them that they are seeing something other than what is there.

► *A simple wood frame, covered in tracing paper and with a light behind it, can surprisingly often substitute for an expensive soft box*

► *People see what they expect to see: the reflection of a window in the teapot, a puff of steam at the spout . . .*

► *An assistant makes it easier to position things like the puff of steam so that they are "set to camera"*

Photographer: **Maurizio Polverelli**

Client: **Mario Formica spa**

Use: **Calendar**

Stylist: **Emanuela Mazzotti**

Camera: **8x10in**

Lens: **360mm**

Film: **Kodak Ektachrome 6117 ISO 64**

Exposure: **f/32½; 8 "hits"**

Lighting: **Electronic flash: 2 heads**

Props and set: **Stone and sandblasted stone**

Plan View

ARIES, THE RAM

▼

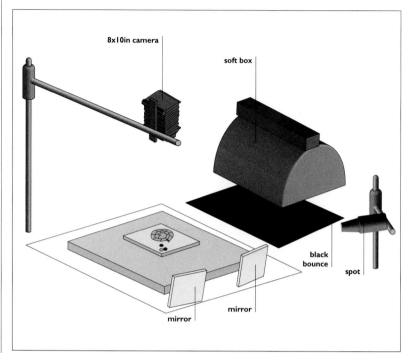

IT IS HARD TO SAY WHAT IS SO ATTRACTIVE ABOUT THIS MINIMALIST STILL LIFE; AND YET THERE IS SOMETHING ABOUT IT. YOU CAN FEEL THE TEXTURES, SMELL THE MUSTY TAR ON THE ROPE… CHOOSING AN 8 × 10IN CAMERA HELPED, OF COURSE: VERY LARGE FORMATS AND AN APOCHROMATIC LENS RENDER TEXTURE LIKE NOTHING ELSE CAN.

Improbably, unless you are familiar with Maurizio's work, the key light is a large, powerful soft box (2500 Joules) sandwiched with a big, black bounce: the light which escapes from the side of the sandwich is soft yet directional. This is at about 10 o'clock from the subject. A much smaller head, just 500 Joules, is set at 2 o'clock: this helps to delineate the precious stones, and it is further supplemented by a couple of small mirrors, as shown. Interestingly, the outer stone rests on a black backdrop to keep flare into the lens to a minimum.

► *The "black bounce" technique is seen elsewhere in Maurizio Polverelli's work in the* Pro Lighting *series*

► *Setting a subject on a black background can reduce flare, even if the black background is entirely out of shot*

► *Multiple "hits" of the flash were necessary in order to work at the desired aperture*

Photographer's comment:

The image represents two precious stones: one of the month (April) and one of the zodiacal sign. The rope represents the ram's horn. The entire image is based on geometrical shapes.

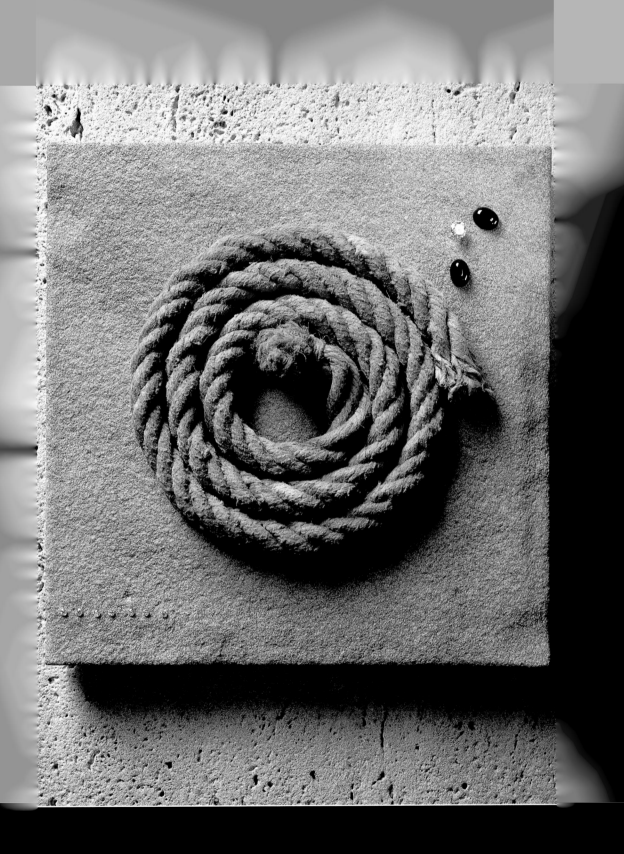

Photographer: **Maurizio Polverelli**

Client: **Mario Formica spa**

Use: **Calendar**

Stylist **Emanuela Mazzotti**

Camera: **8x10in**

Lens: **360mm**

Film: **Kodak Ektachrome 6117 ISO 64**

Exposure: **Not recorded**

Lighting: **Electronic flash: 4 heads**

Props and set: **Sandblasted stone, broken mirror**

Plan View

GEMINI, THE TWINS

▼

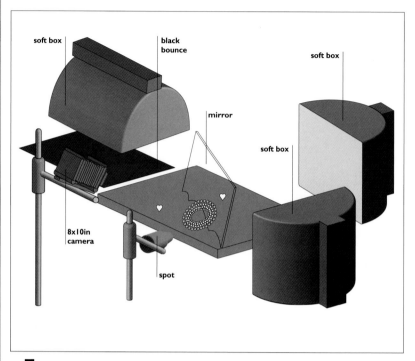

THIS IS NOT A PICTURE WHOSE "MEANING" IS IMMEDIATELY OBVIOUS: A PIECE OF BROKEN MIRROR, OVERARCHING THE SET, DIVIDES THE COMPOSITION INTO TWO NOT-QUITE-EQUAL PARTS. INTO IT YOU CAN READ BOTH CONFLICT AND COOPERATION.

Arguably there is no true key light – the more so as the mirror reflects light from one side, and allows it to pass through the gap from the other. One soft box directly behind the mirror gives one set of highlights; another, on the right at 90° to the camera's line of sight, adds another set; the spot to camera right adds a third set; the soft box with black bounce (something of a Polverelli trade-mark) adds a fourth set; and then there are the reflections from the mirror

The broken edge of the mirror is a powerful design element. The mirror links the two parts of the image (the "Looking-Glass Twin"), but the jagged, razor-sharp edge divides them.

► *Mirrors are tricky to handle – and this is not even a front-silvered mirror*

► *Multiple small points of light are good for creating the illusion of sparkle*

Photographer's comment:

I wanted to show the brightness and the twinkling of the precious stones, so I used a lot of lights. The strange thing is the heart: it's alone, but the mirror creates its duplicate. And the necklace is not a true circle.

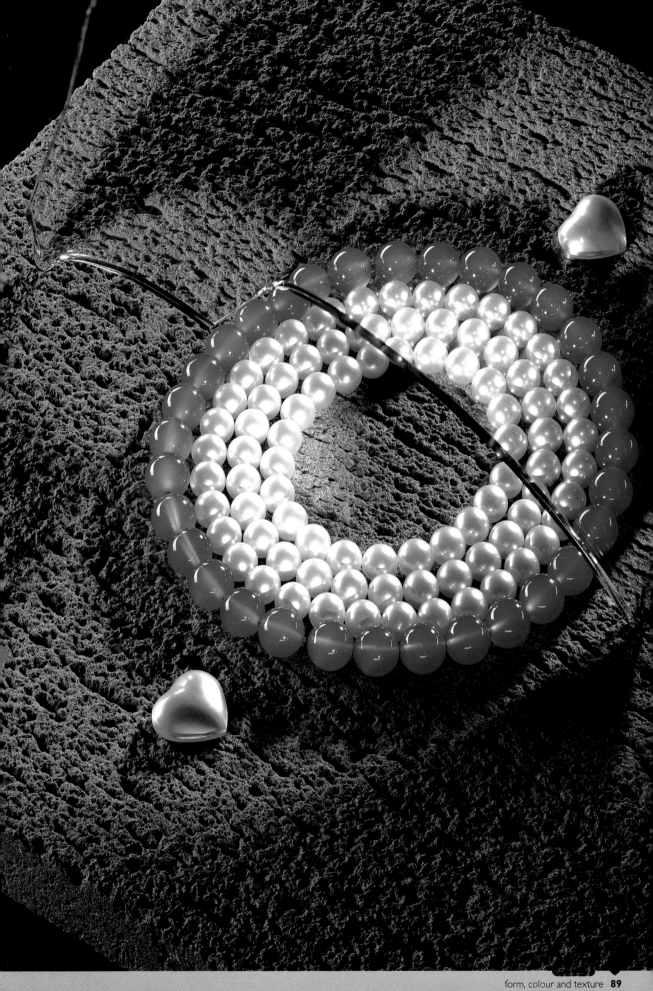

RICOH 66

▼

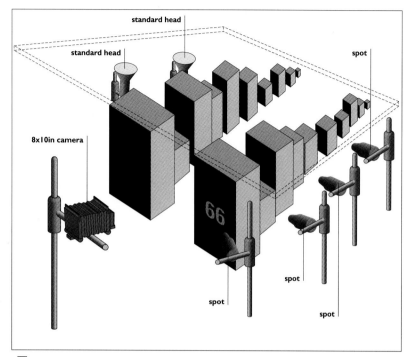

Photographer: **Jay Myrdal**

Client: **Ricoh**

Agency: **Leopard**

Use: **Press Advertising**

Art director **John Batty**

Camera: **8x10in**

Lens: **155mm**

Film: **Kodak Ektachrome 6117 ISO 64**

Exposure: **f/64; 23 "hits"**

Lighting: **Electronic flash: 6 heads**

Props and set: **Painted backdrop**

THERE IS A CURIOUS SENSE OF ENDURANCE IN THIS PICTURE; OF SOMETHING STRONG WHICH HAS ENDURED FOR A LONG TIME. THIS IS VERY MUCH THE QUALITY WHICH THE MANUFACTURER OF A PHOTOCOPIER MIGHT WANT TO PROJECT!

The key lights are four spots to camera right, which together create the hard shadows and the impression of sun coming from infinitely far away: the shadows in the "66" and on the stacks of paper to the left are an essential part of this. They are all filtered half blue, while there is an 80-series blue filter on the camera too. The "sky" is a painted backdrop, lit with two standard heads behind the far stacks.

The stacks of paper are built to create a false perspective – the ones at the back are only 2.5–5cm (1–2in) high – and a 155mm lens still further exaggerates the effect; it is the equivalent of 75mm on 4 x 5in or 21mm on 35mm.

Photographer's comment:

We shot this in plain white, which was the one the client used, and this version, which is the one in my portfolio.

- ► Filtration of lights and filtration on camera can be mixed

- ► When working at very small apertures (for depth of field), numerous "hits" of flash are often required

- ► Large formats are ideal for capturing texture

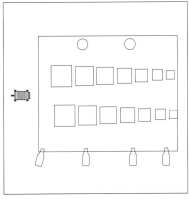

Plan View

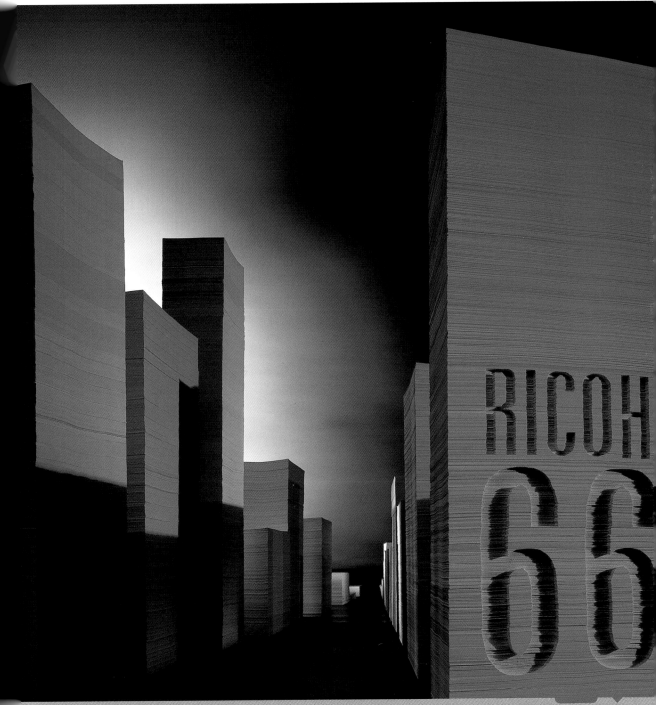

Photographer: **Eros Mauroner**

Use: **Portfolio**

Camera: **8x10in**

Lens: **360mm**

Film: **Polaroid 809**

Exposure: **Not recorded**

Lighting: **Electronic flash: 6 mini spots plus light brush**

Props and set: **Painted-glass backdrop**

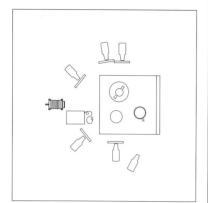

Plan View

► *Balancing light-brushing with other sources can sometimes be demanding*

► *Light intensity and balance can be altered by changing power, by changing distance, by adding filtration (as here), or by making multiple exposures at different apertures*

S E L T Z E R & C O F F E E

▼

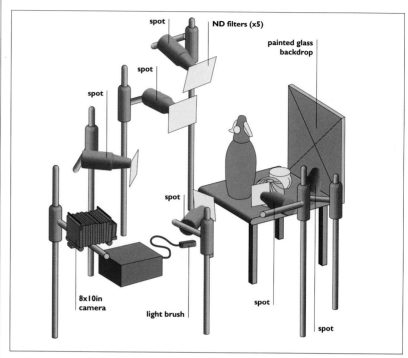

spot — ND filters (x5) — painted glass backdrop — spot — spot — spot — 8x10in camera — light brush — spot — spot

THE PRICE OF 8 × 10IN POLAROIDS IS FRIGHTENING, BUT THE QUALITY OBTAINABLE CAN BE WONDERFUL — AND ENLARGEMENTS UP TO 40 × 50CM (16 × 20IN) ARE QUITE FEASIBLE WITHOUT LOSS OF QUALITY. THIS WAS SHOT ON TYPE 809.

Although a light brush was used for a good deal of the exposure, creating an aesthetic effect which is incontrovertibly interesting, the main technical interest lies in the use of no fewer than six mini spots, all but one with one-stop (2x, ND=0.3) neutral-density filters.

The one which was not filtered was used to illuminate the backdrop of painted glass – in itself an unusual material – while others immediately raise the question: why?

The answer is that, while lights can be moved farther away, this changes the quality of the light and the size (and shape) of the reflections: using ND filters was the easiest way to get exactly the right sort of reflections on the soda syphon, while retaining the desired working aperture for light-brushing.

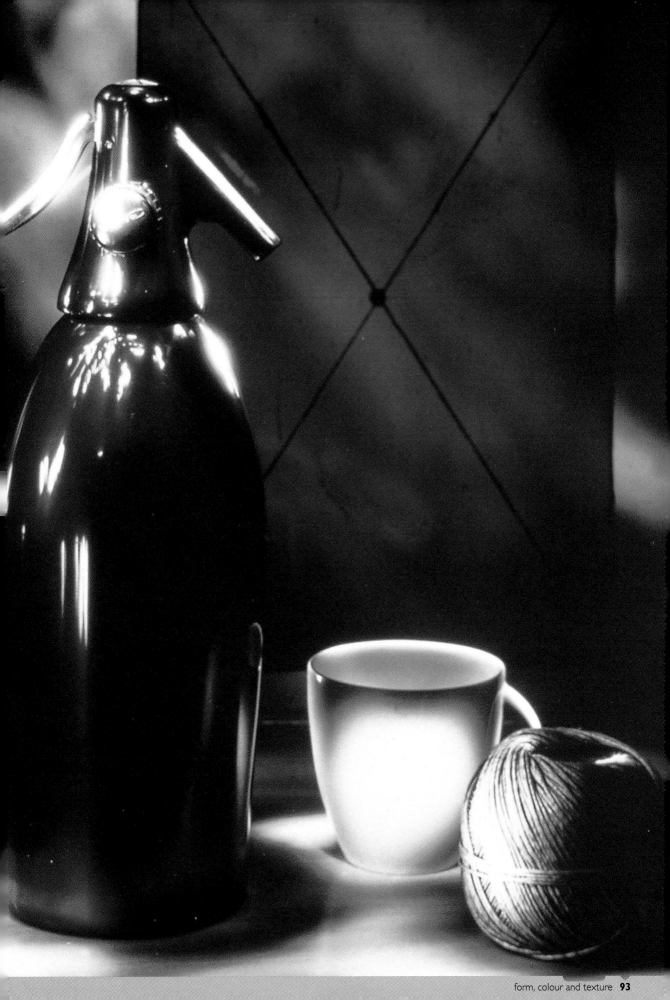

5

still life with

food

▶ It is extremely instructive to compare the pictures In this chapter with the pictures in an earlier Pro-Lighting book on food photography. In food photography the aim is to make the food look appetizing. In a still life the edibility of the food is secondary: we are invited to look at shapes, colours, contours, rather than asked to imagine tastes, smells, textures on the tongue. A different range of senses is engaged, visual rather than tactile or gustatory.

And yet it was not ever thus. Look at painted still lifes: there is typically an attempt to engage far more of the senses. The archetypal rendition of bread, cheese, onion and a tankard of beer is not just an arrangement of shapes: it is very much an arrangement of food that is meant to be eaten. It is quite likely, in fact, that many artists painted their lunch: few artists are rich, especially at the beginnings of their careers, and if you can get double mileage out of cheap, tasty food as both visual inspiration and sustenance it makes excellent sense.

The reason for the separation into food photography and still life probably lies in commercial pressures rather than artistic ones; indeed, many great food photographers describe themselves as still life photographers. And yet, when it came to publication (as already noted elsewhere), we had received far fewer traditional still lifes with food than we had expected.

Photographer: **Michèle Francken**

Use: **Portfolio work**

Camera: **4x5in**

Lens: **210mm**

Film: **Polaroid 559**

Exposure: **f/22**

Lighting: **Electronic flash: 3 heads**

Props and set: **Fruit, artisanal plate**

Plan View

F R U I T

▼

soft box

spot with flash

4x5in camera

spot

A PROBLEM OFTEN FACED BY THE INEXPERIENCED PHOTOGRAPHER IS WHEN TO USE HARD LIGHT AND WHEN TO USE SOFT LIGHT – AND WHEN (AND HOW) TO MIX THEM. MICHÈLE FRANCKEN WELL DEMONSTRATES THE TECHNIQUES HERE, ALONG WITH THE POLAROID EMULSION TRANSFER PROCESS.

► *"Quality" of light is easier to recognize than to describe or analyze*

► *Different aspects of "quality" include directionality, harshness and gradient: a light near a subject will fall off more rapidly than a distant light*

► *Different qualities of light can be combined either naturalistically or in a contrived manner*

The overall lighting ratio is very tight but, because it is a mixture of diffuse and directional lighting, each type of light plays its part. The diffuse light from the overhead soft box gives plenty of detail and texture, while the lower flash head to camera right gives modelling and roundness: look at the shadows on the fruit. Finally, a second spot to camera left is used to back light the dark citrus leaves, which are always a problem to

photograph alongside the fruit.

A perfume spray added the water droplets, and careful choice of props, colours and composition gives the picture considerable impact. All too often photographers experiment with techniques like emulsion transfer using dull images; but if the technique is worth exploring at all, then it must (after the very first experiments to see how it is done) be worth exploring with good pictures.

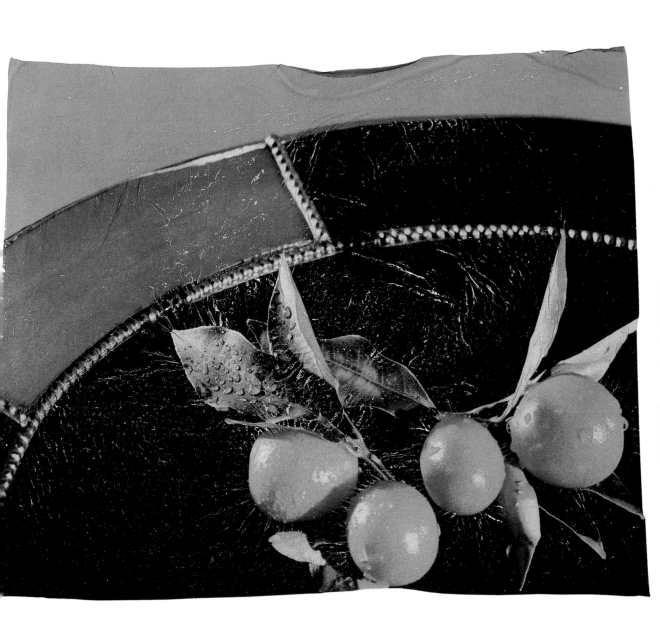

Photographer: **Arici & Mauroner**

Use: **Portfolio/test**

Assistant: **Cristina Canesella**

Camera: **4x5in**

Lens: **180mm**

Film: **Not recorded**

Exposure: **f/16; time not recorded**

Lighting: **Tungsten: one 500W spot**

Props and set: **Pears, hessian**

Plan View

► *A single light source is often a good departure point for experiment*

► *When experimenting, contrast textures such as hessian and pear-skin; the natural world with the man-made; harsh light and soft light*

► *Black bounces frequently have far more effect than you expect*

PEARS

▼

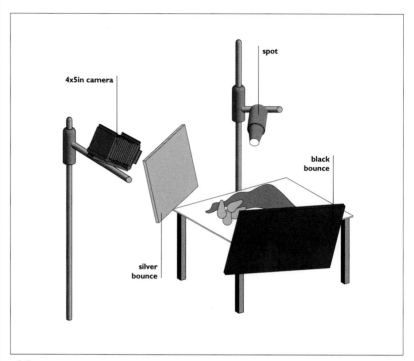

MOST PEOPLE GLANCING AT THIS PICTURE WOULD GUESS THAT IT WAS DONE WITH A LIGHT BRUSH. THE TRUTH, HOWEVER, IS THAT THE SHOT IS BACK LIT WITH A SINGLE 500W SPOT: THE TONALITY IS DUE TO THE USE OF TWO BOUNCE CARDS.

The spot is high, slightly to the left, and slightly back lighting the pears: look at the shadows. The bright highlights are due to the extremely directional nature of the light: they are on the edge of being burnt out, the more so in this duplicate transparency. Their position, which looks subtly wrong (often the sign of light brushing) is due to the shape of the pears, which are strangely asymmetrical.

A silver bounce card to camera left fills the shadow on that side – look at the left-hand pear – but the black bounce to camera right, very close to the camera, absorbs all light from the spot and leaves the shadows below the pears very dark indeed.

Often, just playing with lighting like this – just seeing what will happen – is a successful route to new techniques and portfolio shots.

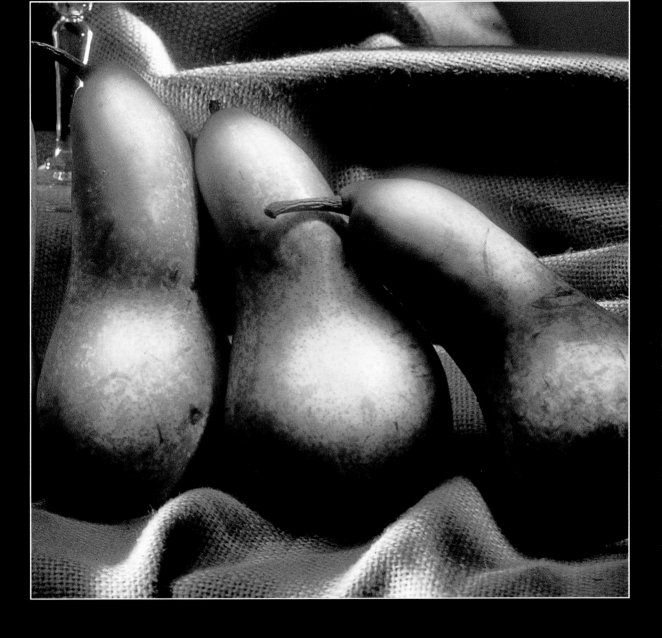

Photographer: **Angelou Ioannis**

Use: **Self-promotion**

Assistant: **Soulis Ioannis**

Camera: **6x7cm**

Lens: **90mm**

Film: **Fuji Velvia RVP ISO 50**

Exposure: **12sec at f/11**

Lighting: **Ultra-violet "black" light**

Props and set: **Garlic (one spray-painted);
brown wrapping paper background**

Plan View

► *"Black" (UV) light is of wavelengths
shorter than about 400nm. Shots in the
near ultraviolet are possible with most
standard lenses down to about 320nm,
and most films are sensitive to this: they
will record it as a very deep violet*

► *Beyond 320nm, UV light is absorbed by
glass, and quartz lenses are required*

► *UV filters on the camera lens will stop
UV recording on the film but will not
affect visible light produced by UV-
fluorescent objects*

G L O W I N G G A R L I C

▼

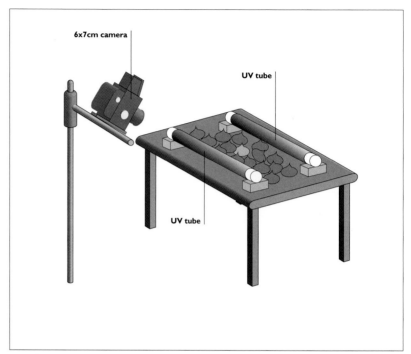

AGAIN AND AGAIN, IN THE COURSE OF PUTTING TOGETHER THESE BOOKS, THE
ORIGINALITY AND INQUISITIVE NATURE OF PHOTOGRAPHERS KEPT COMING THROUGH – AS
DID THE RANGE OF OPTIONS FOR WORKING WITH CONVENTIONAL PHOTOGRAPHY
RATHER THAN ELECTRONICS.

One head of garlic was spray-painted
with (red) fluorescent paint, which glows
under ultra-violet illumination. It was
carefully placed among the other,
unsprayed pieces on a sheet of wrinkled
brown wrapping paper. The two UV
tubes were set up on short strands,
about 10cm (4in) high, as shown in the
diagram. Exposure was based on a spot
meter reading from the glowing head of
garlic, but with extensive bracketing in
the direction of overexposure: from two
stops to four stops more than indicated.
The most successful exposure was 3⅓
stops over the one indicated by the
meter.

Photographer's comment:

*Black light offers a lot of creative opportunities. One can't expect to have similar results with
back lighting, transillumination or a spot. Objects seem to have a life of their own. Colours are
very vivid and unnatural. I wanted a breath of life, a pulse of blood, in a typical still life. Still,
yes; but alive.*

Photographer: **David Dray**

Use: **Stock/library**

Camera: **35mm**

Lens: **100mm + 12mm extension tube**

Film: **Fujicolor ISO 100 (negative)**

Exposure: **f/11**

Lighting: **Electronic flash: 1 head**

Props and set: **Garlic; black background paper**

Plan View

► *Watercolour paper adds its own texture to that of the image*

► *The image is laterally reversed (flop transparencies or negs when making the photocopy)*

► *Use bold, simple compositions with colour copy transfer*

G A R L I C

▼

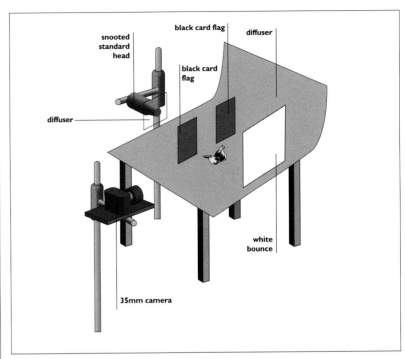

COLOUR PHOTOCOPY TRANSFERS INVOLVE MAKING A COLOUR PHOTOCOPY OF THE SUBJECT, TREATING IT WITH AN ORGANIC SOLVENT, THEN PLACING IT IN CONTACT WITH A SHEET OF WATERCOLOUR PAPER AND RUBBING THE BACK SO THAT THE IMAGE TRANSFERS TO THE NEW SUPPORT.

Colours are usually degraded, but they can also be enhanced in unpredictable and often attractive ways. The original image does not necessarily need to be very sharp because fine detail is lost both in the copying and in the transfer process: the system works best with simple compositions. Because of the transfer the image is laterally reversed.

The lighting is surprisingly complex for a single-head set-up. A snooted standard head to camera left, about 90cm (3ft) from the garlic, is further shaded by a "gate" of black card with a gap some 15cm (6in) wide, but a diffuser is hung over the end of the snoot. A white bounce about 45cm (18in) from the garlic to camera right provides fill.

Photographer's comment:

The use of the colour photocopy technique enhances the simplicity of the study.

Photographer: **Ron McMillan**

Client: **Millenium**

Use: **Catalogue**

Assistant: **Paul Cromey**

Camera: **4x5in**

Lens: **210mm**

Film: **Fuji Provia 100**

Exposure: **f/32½**

Lighting: **Electronic flash: 2 heads**

Props and set: **Red to white graduated ground**

Plan View

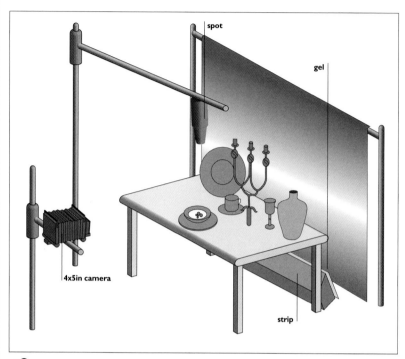

Labels in figure: spot, gel, 4x5in camera, strip

"**S**POT LIGHT" AND "SPOTLIT" ARE VERY RELATIVE TERMS. A PROJECTION SPOT GIVES AN ABSOLUTELY HARD EDGE, WHILE A CONVENTIONAL FOCUSING OR SNOOTED SPOT GIVES A MUCH SOFTER EDGE. OR YOU CAN DEFOCUS A PROJECTION SPOT

Regardless of exactly how you achieve the desired hardness of edge, the success of a picture like this relies heavily on the surroundings to the spotlit area being absolutely dark – which is all the harder to achieve when there is potential spill from the background, as here. Fortunately, there is a psychological phenomenon at work which makes juxtaposed light and dark areas seem to differ more than they actually do.

The lighting set up is a spot overhead, very precisely positioned, and a strip light on the floor behind the table. The strip light is fitted with a yellow gel which transforms the red/white graduated ground to a yellow/orange ground.

► *A dark area next to a very light area will often seem darker than an area of the same dark tone next to a mid-tone*

► *Reflections from the white area (as in the strawberries and the glass) can complement the picture, as here, or they can be an intractable nuisance*

Photographer: **Matthew Ward**

Client: **The Medicus Group (advertising agency)**

Use: **Promotional shot for agency**

Assistant: **Martin Breschinski**

Art director: **Trevor Chapman**

Camera: **4x5in**

Lens: **360mm**

Film: **Kodak Ektachrome EPP**

Exposure: **f/22**

Lighting: **Electronic flash: 5 heads**

Props and set: **120cm (4ft) diameter globe; chilli peppers**

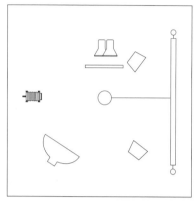

Plan View

H O T S T U F F

▼

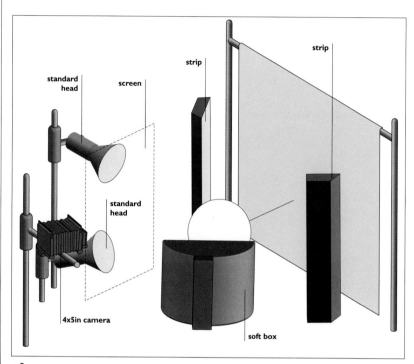

"**I**F WE'D KNOWN WHAT WE WERE GETTING INTO, I'M NOT SURE WE'D HAVE BOTHERED. IT TOOK FOUR OF US – THE ART DIRECTOR, THE ASSISTANT, JULIE NICHOLLS AND ME – A WEEK TO STICK THOSE CHILLIES ON."

Thus Matthew Ward on the logistics of the shot: finding the globe, transcribing the map onto it ("The problem was, we suddenly realized it had to be accurate"), sticking the chillies on, realizing that because the chillies had depth they had to go around behind the globe

After that the lighting was not particularly difficult, though it did take up quite a lot of space: a very large – 120 × 180cm (4 × 6ft) soft box to camera right at 45°, and two standard heads diffused by a huge, 180 × 300cm (6 × 10ft) screen to camera left at right angles to the line of sight. As Matthew put it, "I'm really into soft light sources." The background is lit by two vertical strips.

► *Logistics such as prop hunting and preparation can often be far more time-consuming than the actual shoot*

► *When you have gone to that much trouble it often makes sense to shoot back-up copies (including 35mm and roll-film) for reproduction later*

► *Very large, soft light sources are wonderful as fill lights*

STILL LIFE WITH PEARS

▼

Photographer: **Maria Cristina Cassinelli**

Client: **Alba Paint "One Coat"**

Use: **Packaging**

Designers: **Estudio Avalos & Bourse**

Art Director: **Carlos "Tito" Avalos**

Camera: **4x5in with 6x7cm roll-film holder**

Lens: **210mm**

Film: **Fuji Velvia 120**

Exposure: **$\frac{1}{8}$ sec at f/22**

Lighting: **Electronic flash: 3 heads**

Props and set: **Everything painted a creamy off-white, including the pears**

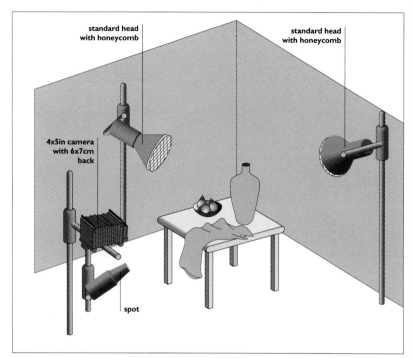

standard head with honeycomb

standard head with honeycomb

4x5in camera with 6x7cm back

spot

Maria Cristina Cassinelli is not just a very accomplished photographer: she is also very good at describing both what she did and why it worked. Here are her comments on the lighting set-up in this shot:

"All the light was provided by two honeycomb grids and one spot. In spite of such contrasty sources there was no need to use any fill-in foam boards. As the set was almost all white, light would bounce all over, creating its own fill-in for the shadows." A further note appears as the "photographer's comment," below, but this is a remarkable example of white-on-white. Each of the three lights performs a very different function. The key light is a honeycombed standard head from camera left, lighting the pears, the pot and the sackcloth. The second light, again a standard head with a honeycomb, illuminates the walls and the corner. Finally, a third light, this time a spot on the floor, lights the side of the table.

Photographer's comment:

The low shutter speed allowed the model lights to warm the picture. I experimented with different speeds and changed a few objects in the set, so I could have a wide variety from which to choose the final shot.

► *White-on-white is not synonymous with high key; indeed, there must be strong chiaroscuro if it is to work at all*

► *The picture would be much weaker if the stems of the pears were also painted white*

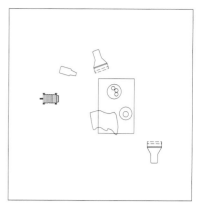

Plan View

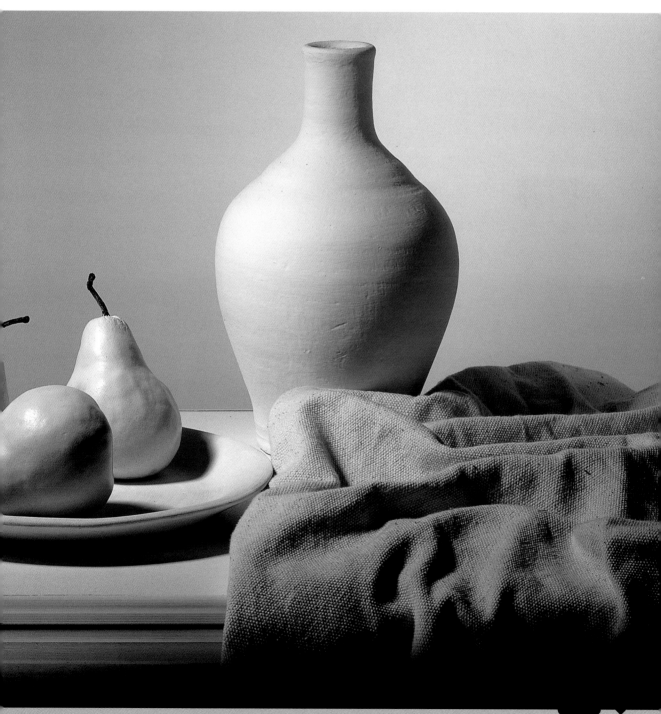

GRAINY BOWL OF FRUIT

▼

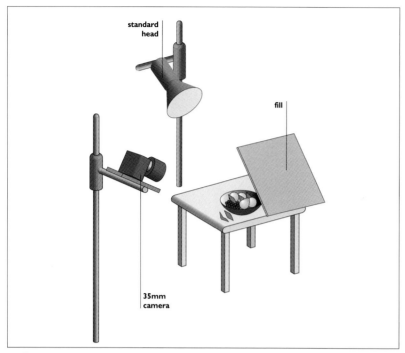

Photographer: **James DiVitale**
Use: **Shot for self-promotion; put into stock; used by printing company**
Designer: **Sandy DiVitale**
Camera: **35mm**
Lens: **135mm**
Film: **Scotch 1000**
Exposure: **f/22**
Lighting: **Electronic flash: 1 head**
Props and set: **Painted background**

Sᴄᴏᴛᴄʜ/3M ISO 1000 ғɪʟᴍ (ᴍᴀᴅᴇ ɪɴ Iᴛᴀʟʏ ʙʏ Fᴇʀʀᴀɴɪᴀ) ᴡᴀs ʙᴇʟᴏᴠᴇᴅ ᴏF ᴍᴀɴʏ ᴘʜᴏᴛᴏɢʀᴀᴘʜᴇʀs. Iᴛs ᴇɴᴏʀᴍᴏᴜs ɢʀᴀɪɴ ᴀɴᴅ ᴅᴇsᴀᴛᴜʀᴀᴛᴇᴅ ᴄᴏʟᴏᴜʀs ᴇᴀʀɴᴇᴅ ɪᴛ ᴛʜᴇ sᴏʙʀɪQᴜᴇᴛ "ᴛʜᴇ ғɪʟᴍ ᴛʜᴀᴛ's sᴏ ʙᴀᴅ, ɪᴛ's ɢᴏᴏᴅ."

The lighting is clear from the illustration: a single standard head, high and to camera left (look at the shadow) and a fill card to camera right (look at the highlights on the "dark" side of the fruit). Positioning the card at an angle lightened the fruit without detracting from the effect of the strong shadow cast by the bowl. To emphasize the grain of the film still further Jim composed the picture in the central area of the 35mm frame, with plenty of room all around – the equivalent, roughly, of shooting on a half-frame (18 x 24mm) camera. Today, though, as he points out, "I can add all the grain I want, or change tonal values or saturation, by using the computer – I just don't need different films any more."

Photographer's comment:

Whenever I work with any materials or equipment, I try to make a virtue out of what others call limitations.

► *The relationship between grain and resolution is complex: a grainy film gives a different effect from a big blow-up off a less grainy film*

► *A grain screen will not work in colour, as the grains are of different colours*

Plan View

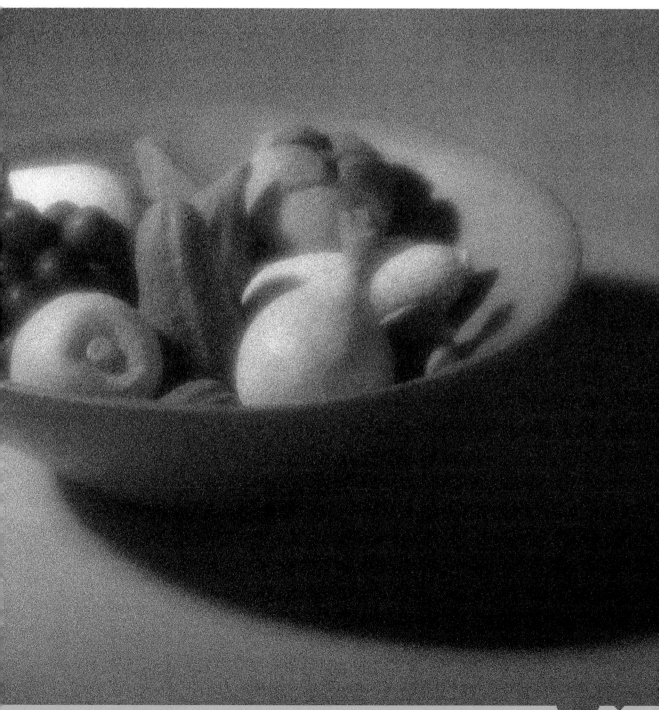

Photographer: **Jay Myrdal**

Use: **Project: "Photographers Do It Both Ways"**

Art director: **Martin Negus**

Camera: **4x5in**

Lens: **210mm**

Film: **Kodak Ektachrome 64**

Exposure: **Not recorded**

Lighting: **Electronic flash: 2 heads**

Props and set: **Built set; backdrop painted by Gordon Aldred**

Plan View

F L Y I N G D I N N E R

▼

AS SO OFTEN WITH JAY MYRDAL'S PICTURES, WHAT YOU SEE IS WHAT WAS THERE: AN INGENIOUSLY BUILT SET, WITH CONSIDERABLE THOUGHT AND INGENUITY BEHIND IT, PHOTOGRAPHED RELATIVELY "STRAIGHT". EVEN THE LABEL ON THE BOTTLE IS SPECIALLY MADE.

The "table" is a relatively narrow board, only about 15cm (6in) in front of the painted background. The "flying" components are suspended by rods or wires through the background, with the exception of the glass, which is suspended on a hollow tube through which water can be pumped. A baffle inside the glass deflects the water so it will splash up as seen here. The glass is suspended behind the "table" and in front of the background, so that spills fall harmlessly to the floor.

The key light is a Fresnel spot to camera left and high, while a big soft box lights the overall set including the background. A rubber tube behind the backdrop holds the water; a hand-bulb squeezes it out. The best exposure was selected from a number of attempts.

► *Model makers can do a great deal – but the photographer has to brief them first*

► *Even after you have the model, it can take a day or more to get everything to work properly*

► *A good enough painter can paint the "lighting" into the backdrop*

Photographer's comment:

This was made for a project in which art directors took the picture while photographers acted as art directors – hence "Photographers Do It Both Ways."

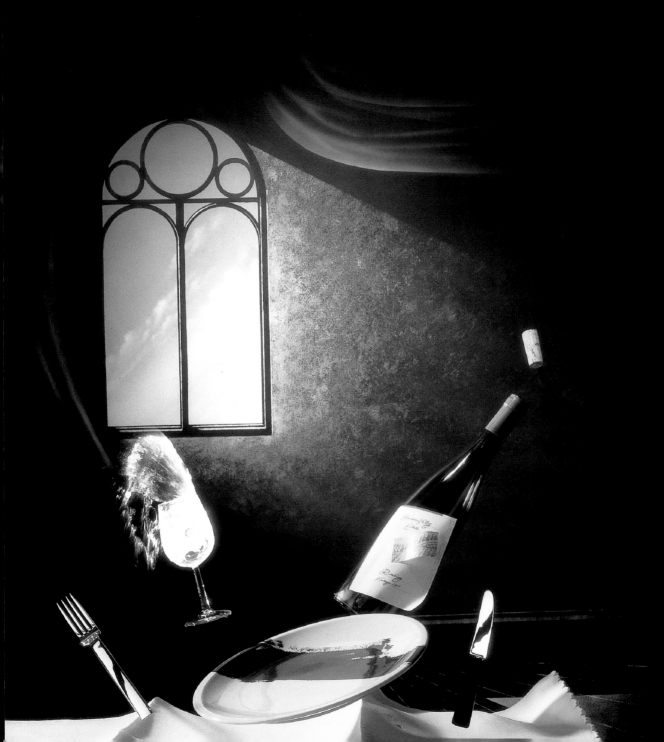

6 commercial
considerations

Most of the photographers whose work is featured in the Pro-Lighting series earn their livings either in the field covered by the book or in some closely related field. Thus photographers of the nude may well submit portfolio or personal work for a book on nudes, but they will also shoot nudes commercially – for pharmaceutical ads, perhaps, or for cosmetics, or even to advertise the benefits of orthopaedic mattresses.

So it is with still lifes, except that there is, if anything, even more of an interplay between commercial work and personal work. Each feeds off the other, as it must. A commercial shoot may prompt the question, "What would happen if I shot it this way?" while a personal shoot may well result in a picture which catches someone's eye and leads to commercial work.

The main thing which distinguishes this chapter from the others is that in most cases trade names are more or less clear in the picture. There are one or two other examples of this in other chapters – Massimo Robecchi's "Poison" in Chapter I, for example – and of course there are plenty of other commercial pictures in the book; but here the emphasis is on commerce and on turning an attractive but not necessarily photogenic subject into a picture which captures some of its glamour, as in Gérard de St. Maxent's "Bijou." A perennial problem in commercial photography, after all, is that many things are designed to be used or worn or consumed or touched, rather than to be photographed, and the photographer's task is to make something of the essence of the subject leak over into the picture.

Photographer: **Nick Wright**

Client: ***Which? Car***

Use: **Editorial**

Assistant: **Kirsty Ashton-Bell**

Art director: **Wayne Campbell**

Camera: **4x5in**

Lens: **180mm**

Film: **Fuji Velvia**

Exposure: **f/32**

Lighting: **Electronic flash: 2 heads**

Props and set: **Built model**

Plan View

WHICH? CAR

▼

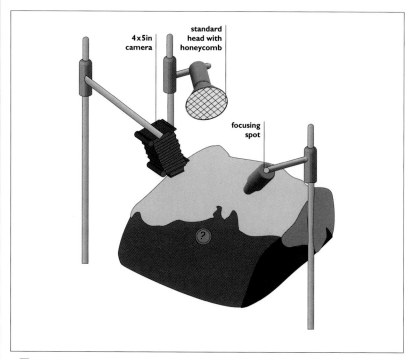

THERE COMES A MOMENT IN THE RELEASE OF ANY NEW CAR WHEN THE PARACHUTE SILK IS PULLED ASIDE AND THE SLEEK AND CURVACEOUS BODYWORK IS REVEALED. THE MANUFACTURER'S BADGE IS OBVIOUSLY OF PARAMOUNT IMPORTANCE — AND HERE IT IS REPLACED WITH A QUESTION MARK.

► *White satin and silk can be fascinating materials to photograph because of their very high reflectivity, which creates dramatic highlights*

► *Re-creating a particular type of lighting is often a question of mood, rather than of detail. Try to imagine that you are present at the type of event which you need to evoke*

► *This model is only about 50cm (20in) square — but the brain "recognizes" it as part of a car*

The difficulty of the shot lay in portraying the ripple of the fabric, without making it look static. As so often, the solution to the problems lay in the lighting. One 3000-Joule head, in a standard reflector with a honeycomb, provided directional lighting with strong highlights. The other, a 2000-Joule focusing spot, was aimed principally at the badge – an obvious symbol for *Which? Car* magazine, a consumer publication – and is still more directional. Also it overexposes the fabric very slightly, re-creating the mood when the lights go down, the spot lights flare up, and the new model is revealed.

Although this could have been done with a real car and a custom-made badge, the bonnet (hood) is also custom-made. In real life it was elegantly curved, but this proved to be the most dramatic angle – with the (expensive) curves invisible.

Photographer's comment:

We also shot this with the shadows of some branches falling on the red metal, but the plain, dramatic red proved to be much more effective.

Photographer: **Marc Joye**

Client: **Browning Sports Division**

Use: **Catalogue, editorial**

Camera: **8x10in**

Lens: **300mm**

Film: **Kodak Ektachrome**

Exposure: **f/22½ (f/27)**

Lighting: **Electronic flash: 1 head**

Props and set: **Maple leaf, dried insect, water**

Plan View

B O R O N F I S H I N G R O D

▼

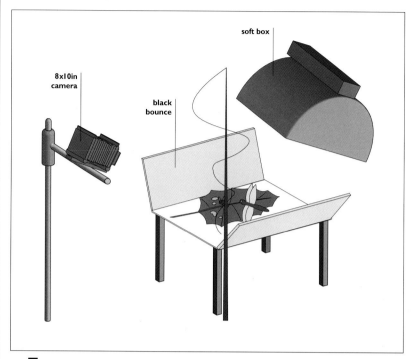

T HE SUCCESS OF THIS PICTURE OWES AS MUCH TO THE ART DIRECTION (DONE BY THE PHOTOGRAPHER) AS TO THE LIGHTING. AND YET THE LIGHTING MUST COMPLEMENT THE PICTURE: SIMULATED SUNLIGHT, FOR EXAMPLE, WOULD HAVE BEEN INAPPROPRIATE.

To make life more interesting the rod is very shiny and reflective, but the maker's name and the rod name had to "read". The answer is a straightforward large soft box, but with large black bounce cards on either side of the set. As the photographer put it, "the soft light gives a reflection in the water drops, and makes the gold lettering on the rod shine; the two black panels were used to give more volume in the fishing rod."

This is an excellent example of the way in which the photographer needs some sympathy with his subject matter. Someone with less imagination than Marc Joye might have found it difficult to create the mood which this shot evokes: you can almost smell the damp air of autumn in this picture, with the fish biting.

► *Colour harmony is often enhanced more by diffuse lighting than by strongly directional lighting*

► *Both black and white bounces may find extensive employment when you are trying to create an impression of roundness*

► *Prop hunting – "styling," when you pay someone else to do it – is an essential part of many types of photography*

Photographer's comment:

The Boron 1500 fishing rod was a newly-created, super-light, super-strong, very flexible rod. I had a free hand to create a photo of it.

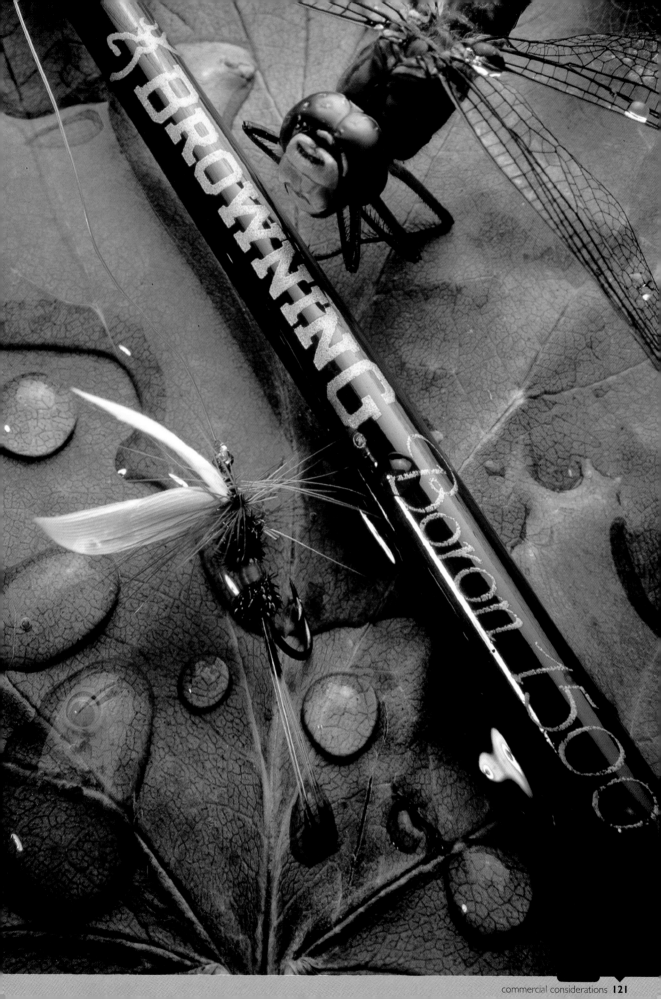

Photographer: **Angelou Ioannis**

Use: **Self-promotion**

Assistant: **Soulis Ioannis**

Camera: **6x7cm**

Lens: **90mm**

Film: **Fuji Velvia RVP ISO 50**

Exposure: **3sec at F/3.8**

Lighting: **Ultra-violet "black light"**

Props and set: **Paper with papyrus texture, fluorescent spray paint**

Plan View

► *"Magic arms" are jointed rods with an "elbow" in the middle and a clamp or other interchangeable support (including camera platforms and lighting holders) at each end. They are immensely useful*

► *Different films may respond very differently to UV light: testing is essential, and Polaroid tests may not necessarily be as informative as usual*

M O N T A N A

▼

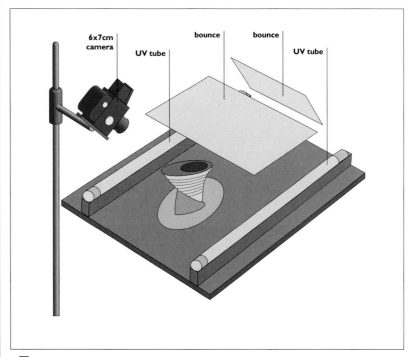

THERE ARE SOME PICTURES WHERE YOU CAN WORK OUT QUITE QUICKLY, AND WITH A FAIR DEGREE OF ACCURACY, HOW THEY WERE SHOT. THEN THERE ARE OTHERS THIS IS DEFINITELY ONE OF THE OTHERS.

The key lights – insofar as the term has meaning – are two 90cm (3ft) "black light" fluorescent tubes either side of the subject. The light-coloured paper background was sprayed with red fluorescent paint in a circle about 15cm (6in) in diameter. When the paint was dry, the perfume bottle was placed in the centre of the circle. Small bounce cards, suspended with Manfrotto (Bogen in the United States) "Magic Arms", reflected some of the fluorescent light back onto the bottle top to lighten it and onto the background to stop it going too dark blue.

Shooting at maximum aperture (f/3.8) for minimum depth of field means that attention is concentrated on the lettering on the top of the bottle – which was emptied, so that it would not be too dark in the picture.

Photographer's comment:

I wanted to portray a colourful yet elegant and ethereal feeling. Using this alternative type of light (black light) I was pleased with the results and the Cibachromes [now Ilfochrome Classic] looked great.

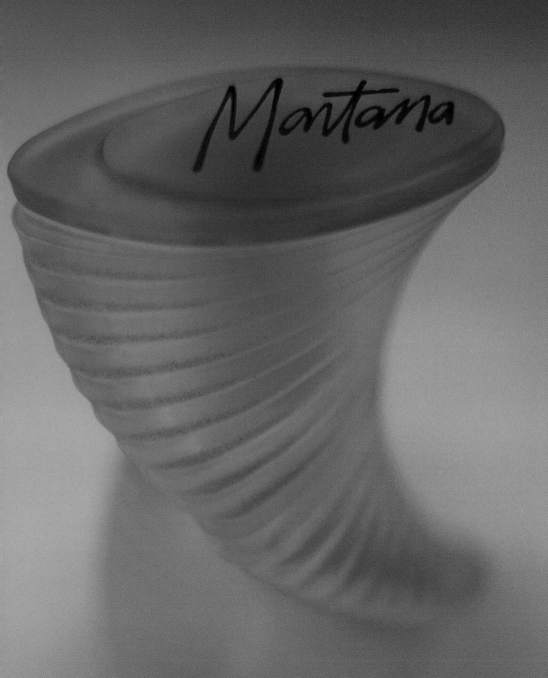

Photographer: **Ben Lagunas & Alex Kuri**

Client: **Corona Beer**

Use: **Poster, magazine advertising**

Assistants: **Dalila Sturat, Isak de Ita, George Jacob, Claudia Vaz**

Stylist: **Michel**

Art director: **Mario Agatti**

Production: **BLAK Productions**

Camera: **4x5in**

Lens: **210mm**

Film: **Kodak Ektachrome EPP ISO 100**

Exposure: **1/60sec at f/16**

Lighting: **Available light + flash**

Props and set: **Artificial beach**

Plan View

THE NATURAL BEER

▼

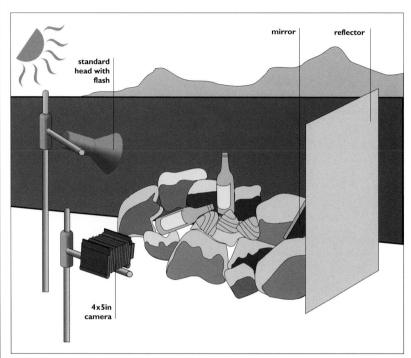

THE BEACH IS "ARTIFICIAL" ONLY INSOFAR AS THE ROCKS WERE ASSEMBLED IN THE FOREGROUND; THE BACKGROUND IS ENTIRELY REAL. THE FOREGROUND IS LIT RATHER MORE BRIGHTLY THAN THE AMBIENT LIGHT, IN ORDER TO MAKE IT STAND OUT.

A large reflector panel to camera right, just out of shot, bounces the sunlight from camera left onto the beer; it is supplemented by a mirror just behind the rocks. Additional lighting came from a standard flash head about 1.5m (5ft) from the subject, just behind the camera and rather above it. The extra height of the flash was necessary to avoid casting shadows from the rocks. The overall exposure is fairly rich, about ⅓ stop below the meter reading: too bright a foreground would look too contrived.

► *There is a fine line between making a foreground stand out and over-lighting it*

► *Slight under-exposure of the foreground, and still more under-exposure of the background, is often most effective*

► *Control of highlights and reflections is important in mixed daylight/flash shots like this*

Photographer's comment:

The ambient light was changing so fast that we had to work quickly and accurately to find the right moment for the shot.

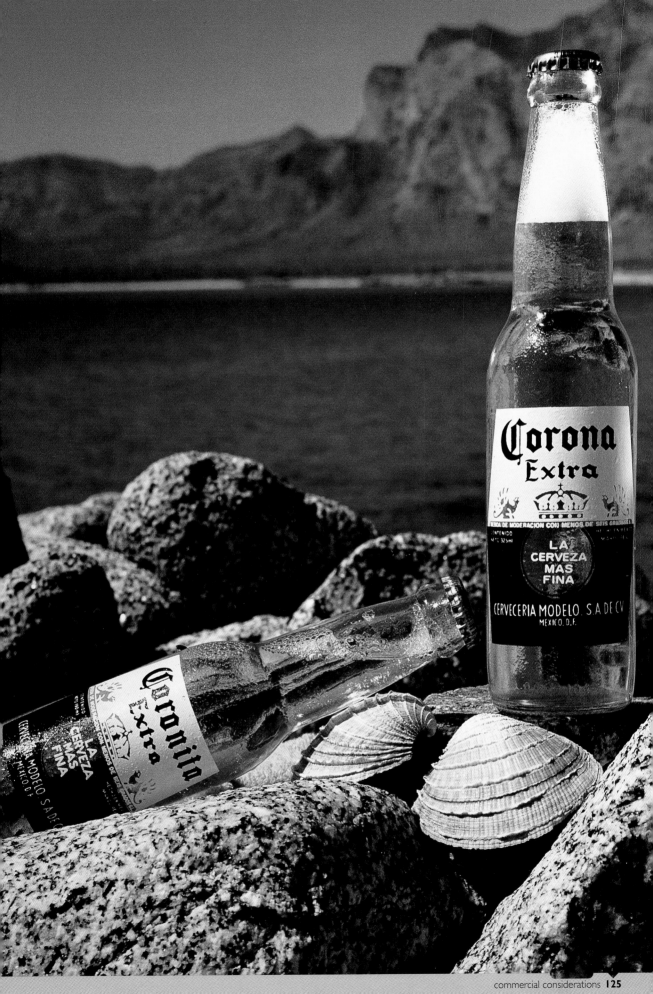

B I J O U

▼

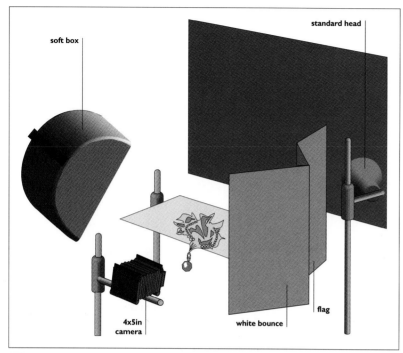

soft box

standard head

4x5in
camera

white bounce

flag

Photographer: **Gérard de St. Maxent**

Client: **Roudier**

Use: **Poster**

Camera: **4x5in**

Lens: **210mm**

Film: **Kodak Ektachrome EPP**

Exposure: **f/8**

Lighting: **Electronic flash: 2 heads**

Props and set: **Glass shelf; blue paper background**

THE CONTRAST OF THE TEXTURES AND FORMS OF THE JEWEL WITH THE ORGANIC FORM AND COLOUR BEHIND IT IS CRUCIAL; SO IS THE USE OF A SOFT BOX INSTEAD OF THE DIRECTIONAL LIGHT OFTEN ADVOCATED AS A MEANS OF CATCHING THE "FIRE" OF PRECIOUS STONES.

The big soft box, 1.5m (5ft) square, to camera left emphasizes the colours and shapes of the jewel – the diamonds are of secondary importance – and contrasts them with the colours and shapes of its support. A white bounce to camera right adds further roundness to the image. The background is lit very dark to further concentrate attention on the jewel. A flag grades the background and another flat stops light bouncing back from the background.

Photographer's comment:

A very wide aperture was used to ensure minimal depth of field.

► Most "fire" comes from the movement of the eye relative to the stone, which does not happen in a photograph, so highly directional lighting is less important than it might seem.

► Techniques and tools for positioning flags and bounces are very important to the still life photographer

Plan View

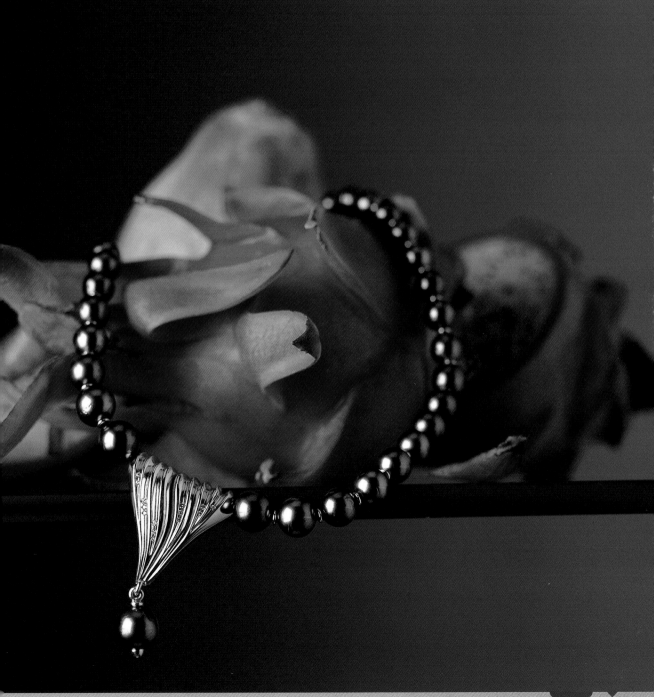

Photographer: **Guido Paternò Castello**

Use: **Self-promotion**

Assistant: **Fernando Ribeiro dos Santos**

Camera: **4x5in**

Lens: **210mm**

Film: **Kodak Ektachrome EPP ISO 100**

Exposure: **f/32**

Lighting: **Electronic flash plus light brush**

Props and set: **Marble slab; after-shave; fishes**

Plan View

▶ *Creating "sunlight" with a light-brush can take a lot of practice and a lot of Polaroids*

▶ *With a shot like this, introduce the fish only when you are satisfied with the Polaroids for the rest of the shot*

▶ *Transillumination with hot lights has been known to kill small fish*

A F T E R S H A V E W I T H F I S H E S

▼

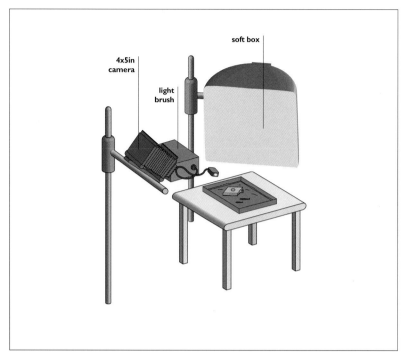

THIS SHOT IS ALL THE MORE REMARKABLE WHEN YOU REALIZE THAT IT IS A SELF-PROMOTIONAL PIECE: A SUPERB CONCEPT, AS EVERYONE ASSOCIATES SMALL FISH WITH COOL, CLEAN WATER. YOU CAN ALMOST FEEL THE FRESHNESS.

As is normal in a light-painted image there is a base exposure – made, in this case, with an electronic flash, which also helps to freeze the movement of the fish and avoids over-heating them – which was then supplemented with the light brush, creating the apparently sunny directionality of the light. The angle of the soft box can clearly be seen from the shadows below the two small fishes in the lower right-hand corner.

The only drawback to this shot is that it violates the old actors' adage never to work with children or animals: those fish will go just about anywhere except where you want them. The image as printed here is taken from a computer output.

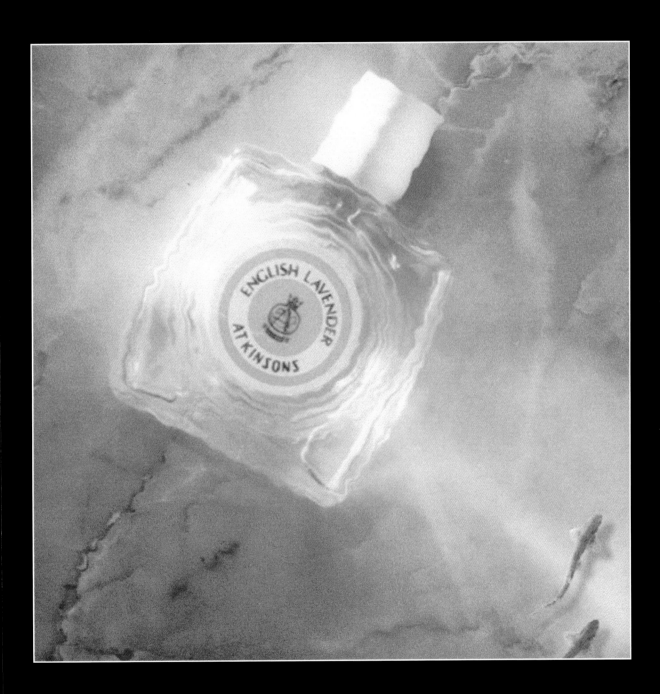

Photographer: **Jay Myrdal**

Client: **Ricoh**

Agency: **Leopard**

Use: **Trade press**

Assistant: **Peter Day**

Art Director: **Roland Haynes**

Camera: **8x10in**

Lens: **155mm**

Film: **Kodak Ektachrome 6117 ISO 64**

Exposure: **f/32½; multiple/long exposure**

Lighting: **Electronic flash: 8 heads**

Props and set: **Photocopier; paper; tables to hold paper**

Plan View

P H O T O C O P I E R

▼

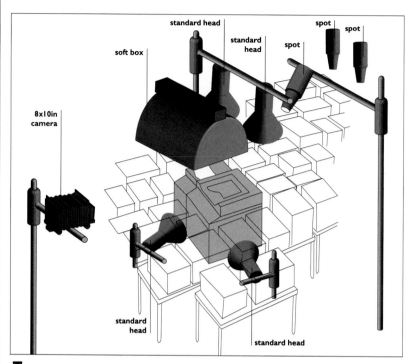

THE ILLUSION IS, OF COURSE, OF A COPIER SURROUNDED BY STACKS OF PAPER AS HIGH AS IT IS — AND NO DOUBT IT COULD DO IT. BUT FOR PHOTOGRAPHY A QUICKER, EASIER ROUTE WAS NECESSARY.

The copier is surrounded with tables on which the copies are stacked. Under the tables, in front of the machine and to camera right, there were two standard heads to light the front and side of the machine.

A big overhead soft box provided general illumination (look at the soft shadows on the copier), while three more heads also light the copier — two standard heads with spill kills, and one spot slightly back lighting the machine from the right to create the modelling and the highlights on the top. Two more spots create the pools of light on the background. After multiple "hits", the lights were all killed and the machine was run for at least 50 times to record the light on the control panel.

► *Very long exposures are frequently necessary to record warning lights, illuminated control panels and the like*

► *With a shape as complex as the top of the copier, multiple shadows are rarely too obvious*

Photographer: **Struan**

Use: **Portfolio**

Camera: **35mm**

Lens: **24mm lens + close-up lens**

Film: **Kodak Ektachrome EPN 100**

Exposure: **1/4sec at f/16**

Lighting: **Daylight**

Props and set: **Translucent cellophane**

Plan View

► *Deliberate camera movement can be very effective*

► *Try movement-induced blur with and without flash*

► *If you can, try second-curtain synch as well as normal first-curtain synch*

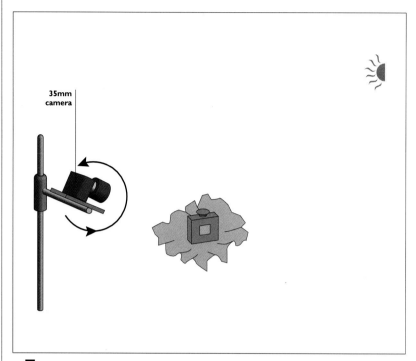

"TRY IT!" IS THE MESSAGE FROM THIS PICTURE. IF YOU SAY TO YOURSELF, "I WONDER WHAT WOULD HAPPEN IF . . .", THEN IT IS GENERALLY QUICKER AND MORE RELIABLE TO TRY IT FOR YOURSELF THAN TO ASK SOMEONE ELSE.

The technique is unbelievably simple. The perfume bottle was resting on translucent cellophane, and the camera was spun very quickly anti-clockwise around the optical axis for a range of exposures form $1/15$ to $1/2$ sec – always keeping the label in the centre of the field, thereby minimizing the impact of the spin at that point while maximizing it at the outer edge of the picture. This was the exposure which worked best.

The lighting is even simpler: daylight. It is the sort of picture which inspires you just to go out with your 35mm camera and a wide-angle lens and start spinning it at things. The wide-angle lens reduces the effect of camera shake and increases the apparent movement at the outer edge.

Photographer's comment:

This was originally to be used for a promotion for a new printing company, but it never ran.

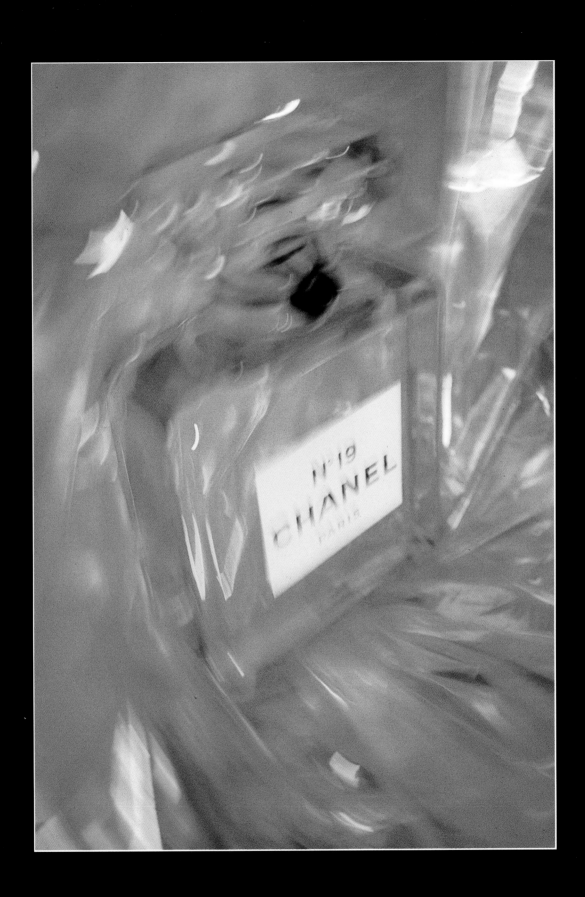

Photographer: **Jay Myrdal**

Client: **British Airways**

Agency: **Equator**

Use: **Brochure cover, world-wide advertising**

Assistant: **Peter Day**

Art director: **Simon Panton**

Camera: **8x10in**

Lens: **210mm**

Film: **Kodak Ektachrome 6118 ISO 64 Tungsten**

Exposure: **Multiple exposure at f/45**

Lighting: **Tungsten: 4 heads**

Props and set: **Model aircraft fuselage; built reflector**

Plan View

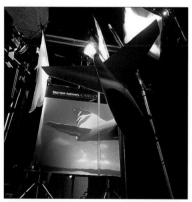

Reference 1

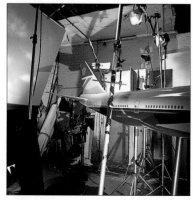

Reference 2

B A C A R G O

▼

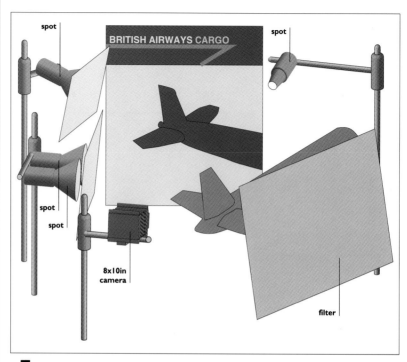

Tungsten was used for a very hard light on the tail, to create the illusion of sunlight: look at the shadows. The light was also warmed slightly with filters.

Two more tungsten lights, diffused through tracing paper, light the "sky", and another (again diffused) provides fill on the tail. You can work out a lot from the accompanying reference shots, taken during the shoot. Reference 1 is shot from the camera position: you can see how diffused tungsten lamps light the "sky" (out of shot to camera right) and the tail. Reference 2 shows the "sky" (upper left), the tail-piece and camera, and the back of the panel as shot (centre right).

The tail-piece is about 4m (13ft) long and was on loan from BA. The thing in which it is reflected – seemingly another aircraft – was built by Model Solutions from metallized Formica. There is also a large screen, painted blue with black fabric along the bottom, which is reflected as the "sky".

► *Jay used three exposures in sequence with different lights on the tail and the sky in order to balance the intensities of the three lights*

► *Tungsten diffused through tracing paper can be used in much the same way as a soft box*

7

exploring
concepts

▶ Because of the extraordinary range of subject matter, techniques, and ideas inherent in a book about still life photography, this last chapter is something of a catch-all for ideas which do not quite fit elsewhere.

Insofar as there is a unifying factor – and we admit that it is on occasion tenuous – the thing about the pictures in this chapter is that they are designed to create a mood rather than to represent physical objects. The physical objects are of course essential, but they are in a sense secondary to the message they carry: Maurizio Polverelli's "Suburban Sport" is about the streets of New York rather than being a mere representation of some clothing; Jay Myrdal's "Exploding Pig" is about saving and spending; Johnny Boylan's "Lost Property" is about timelessness and nostalgia, days and values now only half-remembered.

One thing that most of these pictures have in common is that they involve more or less elaborately contrived assemblages of objects – though the size of the subject is not necessarily any guide to the complexity or difficulty of setting it up, as Peter Laqua's "Durchblick" illustrates. Some sets are relatively simple; some required fairly demanding prop-hunting; and some involve models, and more than touch upon special effects. As in the other chapters, the photographers have employed a wide variety of lighting techniques, so no generalizations can be drawn there, and the chapter reflects the overall composition of the book as far as formats are concerned, with four 4 x 5in images, two 8 x 10in and two rollfilm.

Photographer: **Benny De Grove**

Use: **Exhibition**

Stylist: **An De Temmerman**

Camera: **6x6cm**

Lens: **50mm**

Film: **Polaroid (emulsion transfer)**

Exposure: **f/22**

Lighting: **Electronic flash: 2 heads**

Plan View

E V O L U T I O N O F M A N K I N D

▼

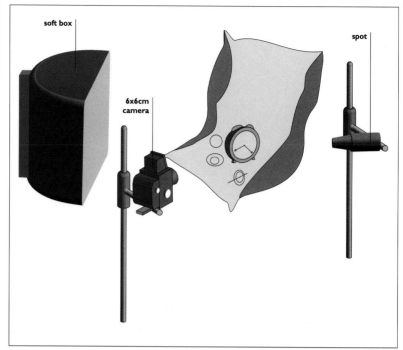

EMULSION TRANSFER — WHICH INVOLVES PHYSICALLY FLOATING THE EMULSION OFF A POLAROID PRINT AND TRANSFERRING IT TO ANOTHER SUPPORT, USUALLY WATER-COLOUR PAPER — OFFERS CONSIDERABLE OPPORTUNITIES FOR IMAGE MANIPULATION.

The shadows are important, so the key is a highly directional spot, from camera right, very slightly back lighting the subject. An 80 x 80cm (32 x 32in) soft box to camera left provides some fill, but principally adds highlights on the left side of the image around the rim of the battered clock.

Some photographers prefer to work with originals, while others shoot an original on conventional chrome and then duplicate it onto Polaroid in order to allow several different manipulations to be tried on a single identical image. Of course, the shot can be left set up, and several originals can be shot.

► *A highly directional spot will still cast distinct shadows in the face of quite a strong fill, if the fill is soft enough*

► *Highlights on battered metal can be very effective*

Photographer's comment:

As I wanted long shadows, the light had to be very low. The figures on the clock were reversed to accentuate the impression that something is going wrong in the evolution.

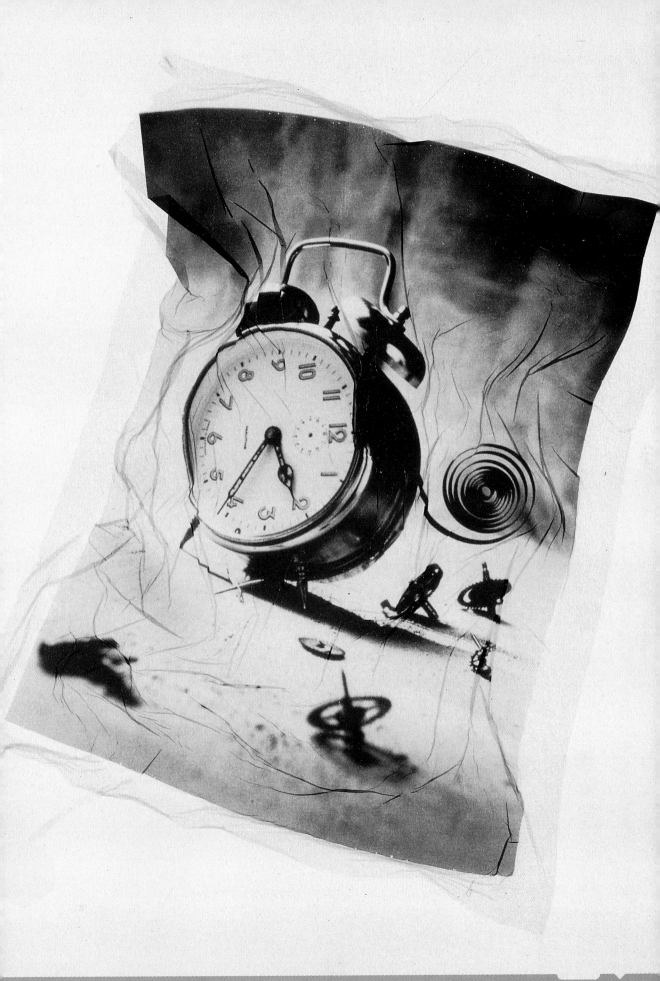

Photographer: **Roger Hicks**

Client: *Shutterbug* **magazine**

Use: **Editorial**

Assistant: **Frances Schultz**

Camera: **6x7cm**

Lens: **135mm**

Film: **Fuji Velvia RVP**

Exposure: **1sec at f/11**

Lighting: **Mixed: see text**

Background: **1930s wooden table top**

Plan View

▶ *Careful positioning of picture elements may be needed to minimize (or maximize) reflections*

▶ *One of the coins is held in position with a small piece of silicone putty*

▶ *A miniature technical camera (Linhof) allowed control of depth of field*

A V I A T O R

▼

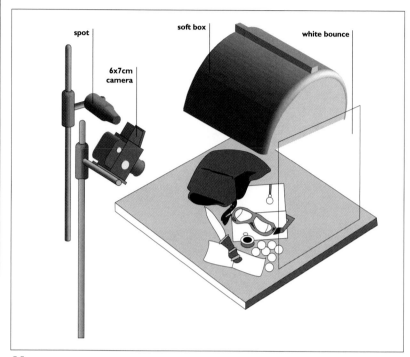

Vᴇʟᴠɪᴀ ɪs ᴀɴ ᴜɴꜰᴏʀɢɪᴠɪɴɢ ꜰɪʟᴍ ʙᴜᴛ ɪᴛ ᴅᴇʟɪᴠᴇʀs ʀᴇᴍᴀʀᴋᴀʙʟᴇ sᴀᴛᴜʀᴀᴛɪᴏɴ ᴀɴᴅ sʜᴀʀᴘɴᴇss ɪꜰ ʏᴏᴜ ɢᴇᴛ ɪᴛ ʀɪɢʜᴛ. Tʜɪs ᴡᴀs sʜᴏᴛ ᴛᴏ sᴇᴇ ʜᴏᴡ ɪᴛ ʀᴇᴀᴄᴛᴇᴅ ᴛᴏ ᴍɪxᴇᴅ ʟɪɢʜᴛɪɴɢ: ᴀ 1200-Jᴏᴜʟᴇ sᴏꜰᴛ ʙᴏx ᴏᴠᴇʀʜᴇᴀᴅ ᴀɴᴅ ᴀɴ 800W ᴛᴜɴɢsᴛᴇɴ ʟɪɢʜᴛ ᴛᴏ ᴄᴀᴍᴇʀᴀ ʟᴇꜰᴛ.

The two lights were "juggled" by varying the shutter speed, which increased or decreased the effect of the tungsten light without varying the effect of the flash, which depends solely on aperture. The only easy way to do this is with plenty of Polaroid: eight or 10 sheets must have been used up on this project.

The key light is the 800W focusing spot to camera left, set as tight as possible to create the illusion of the setting sun, while the fill is the overhead soft box for the "sky". Two small white bounces, one behind the shot and one to camera right, helped to differentiate the flying helmet from the similarly coloured table.

Photographer's comment:

The knife, coins and text are Tibetan; the linen-backed map dates from the 1920s.

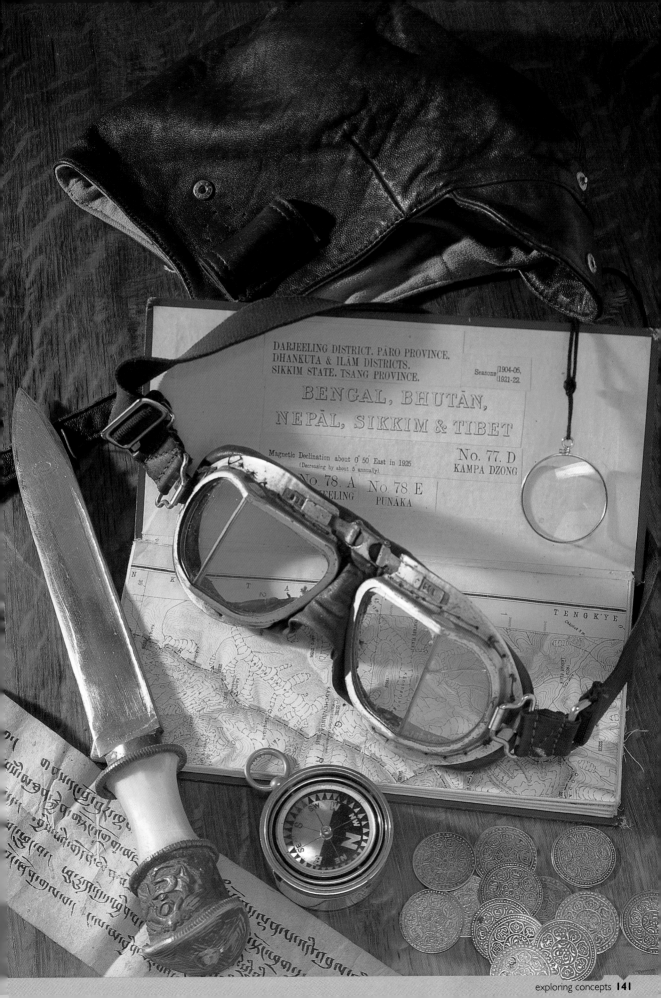

DURCHBLICK

▼

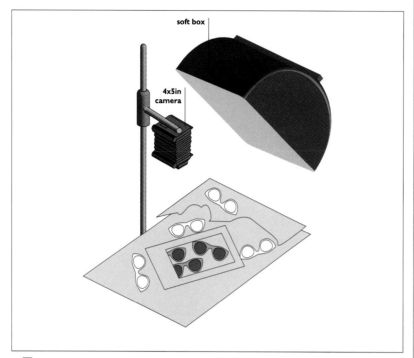

soft box

4x5in
camera

Photographer: **Peter Laqua**

Client: **Brillen-Optiker**

Use: **Poster**

Camera: **4x5in**

Lens: **210mm**

Film: **Fuji Provia**

Exposure: **Not recorded**

Lighting: **Electronic flash: one soft box**

Props and set: **Sunglasses, corrugated cardboard, white spray**

THIS IS A TRIUMPH OF SET-BUILDING. ANY PHOTOGRAPHER WHO GLANCED AT THE IMAGE WOULD "SEE" A POLAROID. EXCEPT, OF COURSE, THAT IT ISN'T A POLAROID. THE "POLAROID" FRAME IS CUT FROM CARDBOARD, AND THAT PART OF THE IMAGE IS NOT SPRAYED WHITE.

The only give-away (and you have to examine the picture closely to see it) is the shadow of the upper part of the "Polaroid", opposite the tear-off tab. The sole light is a 1 x 1m (39 x 39in) soft box as illustrated; the highlight on one spectacle lens gives you a pretty good idea of where it is. Once you have an idea like this, the real secret lies in working out how to do it and in trying different materials (this looks very like special-effects snow) to realize your vision.

► Companies catering to the movie business often offer a wide array of special-effects materials

► A simple soft box gives very different effects on dull, matte surfaces and on shiny surfaces

► A large soft box, used close, minimizes unwanted shadows from the frame but gives clear shadows on the glasses and cardboard

Plan View

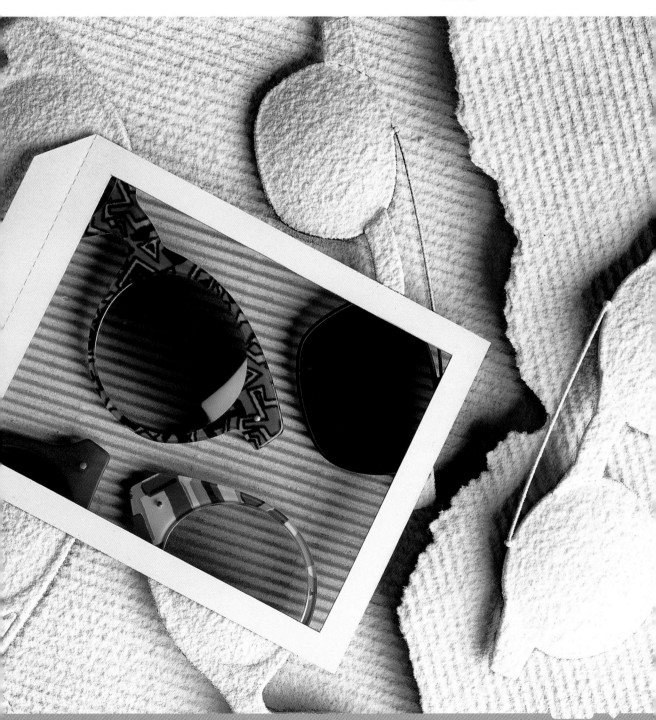

ANNÄHERUNG

▼

Photographer: **Peter Laqua**

Use: **Exhibition**

Camera: **4x5in**

Lens: **210mm macro**

Film: **Kodak Ektachrome**

Exposure: **Not recorded**

Lighting: **Electronic flash: 1 head**

4x5in camera

soft box

A GERMAN PHOTOGRAPHER GIVES THE LIE TO AN OLD ENGLISH SAYING, "ALIKE AS TWO PEAS IN A POD". THE APPEAL OF THIS PICTURE LIES IN PRESENTING SOMETHING VERY RECOGNIZABLE IN A FORM WHICH IS MOST UNUSUAL.

The lighting is exactly what it seems to be: a soft box used as a light table. The peas are obviously chosen to give the right combination of transparency and opacity: for such a shot, it is sometimes necessary to haunt the shops for several days until precisely the right product comes in. Then you need to select the peas carefully, and persuade the shop not to damage them as they weigh and pack them. After the logistics come the aesthetics . . .

It may also be necessary to mask the area outside the shot with black paper in order to avoid flare, although this is less of a problem with multi-coated lenses.

► *It is sometimes difficult to anticipate the effects of powerful transillumination*

► *Massive depth of field is not essential, as you do not see "into" the subject: you see shadows on the surface of it*

Plan View

Photographer: **Maurizio Polverelli**

Client: **Champion**

Use: **Portfolio**

Stylist: **Emanuela Mazzotti**

Camera: **8x10in**

Lens: **300mm**

Film: **Kodak Ektachrome 64**

Exposure: **Not recorded**

Lighting: **Electronic flash: 5 heads**

Props and set: **Painted wall**

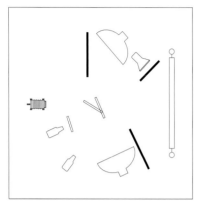

Plan View

▶ *Using separate poles to create the background shadow solves the awkward problem of the shadows of the clothes on the poles*

▶ *The shot reflects the old newsman's adage: when faced with a choice between truth and legend, print the legend*

S U B U R B A N S P O R T

▼

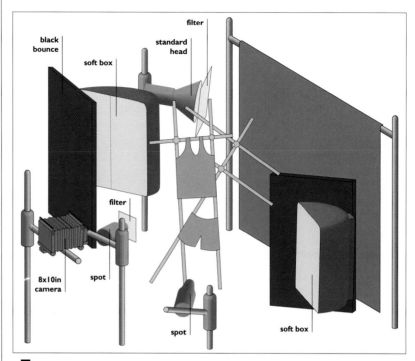

T HE LIGHTING ON THIS SET IS SURPRISINGLY COMPLEX, WITH TWO SPOTS, TWO SOFT BOXES AND A STANDARD HEAD – AND THE KEY LIGHT IS THE PHOTOGRAPHER'S UNUSUAL BUT ALMOST TRADE-MARK SET-UP OF A SOFT BOX PLUS A BLACK BOUNCE.

This key is a large soft box 100 × 150cm (40 × 60in) to camera left, directly opposite a black bounce. It provides the highlights on the satin shorts and the support poles; the quality of light is different from either a strip light or a plain soft box. The other soft box acts principally as a fill; you can work out its precise location from the reflections on the right-hand side of the support poles.

A blue filtered spot to camera right increases the intensity of the colour of the outfit, while another spot throws the shadows of the support poles onto the background: these echo the shapes of the poles (which themselves are reminiscent of builders' scaffold poles) but they are not the shadows of the poles in shot. Finally, another blue filtered head lights the background.

Photographer's comment:

Basketball is an American game; people play it in the streets, surrounded by painted walls.

L E O

▼

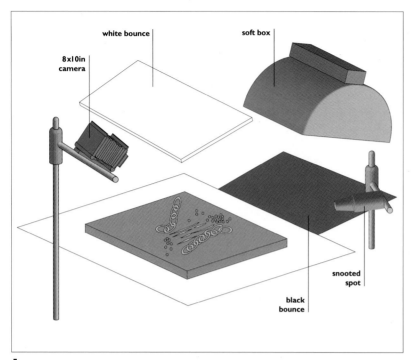

Photographer: **Maurizio Polverelli**

Client: **Mario Formica spa**

Use: **Calendar**

Stylist: **Emanuela Mazzotti**

Camera: **8x10in**

Lens: **360mm**

Film: **Kodak Ektachrome 64 (6117)**

Exposure: **Not recorded**

Lighting: **Electronic flash: 2 heads**

Props and set: **Scratched stone; chain; semi-precious stones**

Lᴋᴇ "Sᴜʙᴜʀʙᴀɴ Sᴘᴏʀᴛ" ᴏɴ ᴛʜᴇ ᴘʀᴇᴠɪᴏᴜs ᴘᴀɢᴇ ᴛʜɪs ᴘɪᴄᴛᴜʀᴇ sʜᴏᴡs ᴛʜᴇ ᴜsᴇ ᴏғ Mᴀᴜʀɪᴢɪᴏ Pᴏʟᴠᴇʀᴇʟʟɪ's ᴜɴᴜsᴜᴀʟ ʙᴜᴛ ᴇғғᴇᴄᴛɪᴠᴇ ᴛᴇᴄʜɴɪǫᴜᴇ ᴏғ ᴄᴏᴍʙɪɴɪɴɢ ᴀ sᴏғᴛ ʙᴏx ᴀɴᴅ ᴀ ʙʟᴀᴄᴋ ʙᴏᴜɴᴄᴇ ғᴏʀ ᴀ sᴏғᴛ ʏᴇᴛ ᴅɪʀᴇᴄᴛɪᴏɴᴀʟ ғɪʟʟ.

The key, is however, the snooted spot to camera right, back lighting the image; look at the highlights on the chain. The soft box is to camera left, with the black bounce on the same level as the table. A white bounce directly over the subject further softens and diffuses the light, while still leaving it clearly directional.

The direction of the key echoes the direction of the scratch marks, and compositionally the picture is interesting because of the conflicting diagonals of the scratch marks and the right-hand chain with the left-hand chain. It is one of those pictures where everything looks obvious – and where you suddenly realize that, to make a picture that natural, you have to take a lot of trouble.

Photographer's comment:

All of us remember the lion as the strong animal which fought the slaves in the days of the Roman Empire. The positioning of the stones helps emphasize the movement of the lion's arm.

► The simpler the still life, the stronger the composition must be

► The ultra-large 8 x 10in format captures texture beautifully

► Good prop hunting is essential; it would be all too easy to realize this idea only partially

Plan View

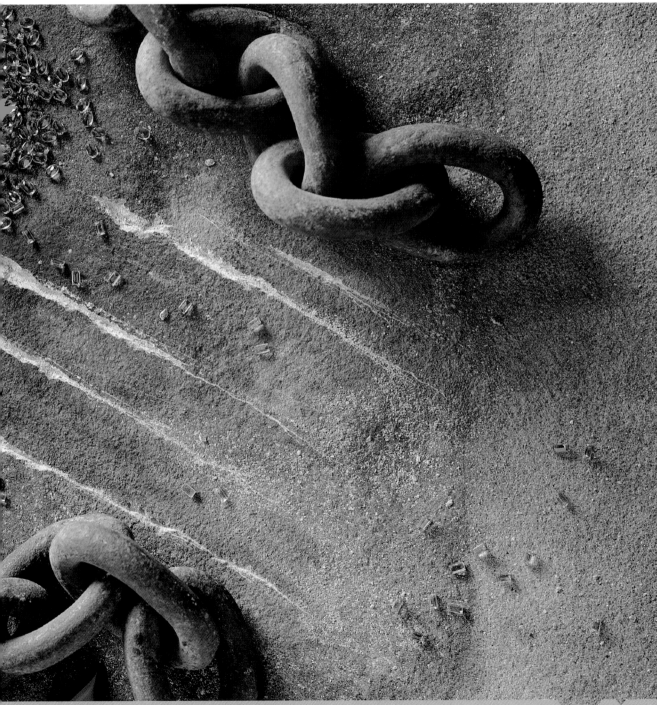

LOST PROPERTY

▼

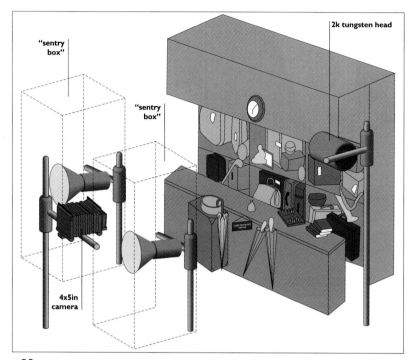

"sentry box"

"sentry box"

2k tungsten head

4x5in camera

Photographer: **Johnny Boylan**

Client: *Southside* **Magazine**

Use: **Editorial**

Camera: **4x5in**

Lens: **180mm**

Film: **Fuji Velvia ISO 50**

Exposure: **1½sec at f/22½**

Lighting: **Mixed flash and tungsten**

Props and set: **Client's luggage in built set**

Yᴏᴜ ᴄᴀɴ ᴀʟᴍᴏsᴛ sᴍᴇʟʟ ᴛʜᴇ ᴅᴜsᴛ ᴏɴ ᴀ ᴛɪᴍᴇʟᴇss ᴀfᴛᴇʀɴᴏᴏɴ; sᴏᴍᴇ ᴏf ᴛʜɪs sᴛᴜff ʜᴀs ʙᴇᴇɴ ʜᴇʀᴇ sɪɴᴄᴇ ᴛʜᴇ 1930s Of ᴄᴏᴜʀsᴇ, ɪᴛ ɪs ᴀ ʙᴜɪʟᴛ sᴇᴛ, fᴏʀ ᴀɴ "ᴀᴅᴠᴇʀᴛᴏʀɪᴀʟ" fᴇᴀᴛᴜʀᴇ ᴏɴ ʟᴜɢɢᴀɢᴇ.

The main light comes from a lot of flash power – about 10,000 Joules – bounced into "sentry boxes" of white expanded polystyrene sheets 240 × 120cm (8 × 4ft) and faced with tracing paper. The effect is to create a giant soft box, for a very flat, soft light. Then, a 2K tungsten light from camera right was set to graze along the front of the set as if it were late afternoon or early evening sun coming through a window. The overall effect is as if the sun were being diffused in dusty air, perhaps supplemented by a couple of dusty skylights in the ceiling. The colour of late sunlight is similar to that of tungsten lighting, so this flash-plus-tungsten technique on daylight-balanced film is of general application.

► Building big soft boxes is a useful
 technique but requires a lot of power

► Tungsten lights run at 3200° or
 3400°K; setting sun can run as low as
 2800°K

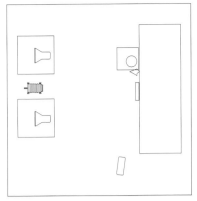

Plan View

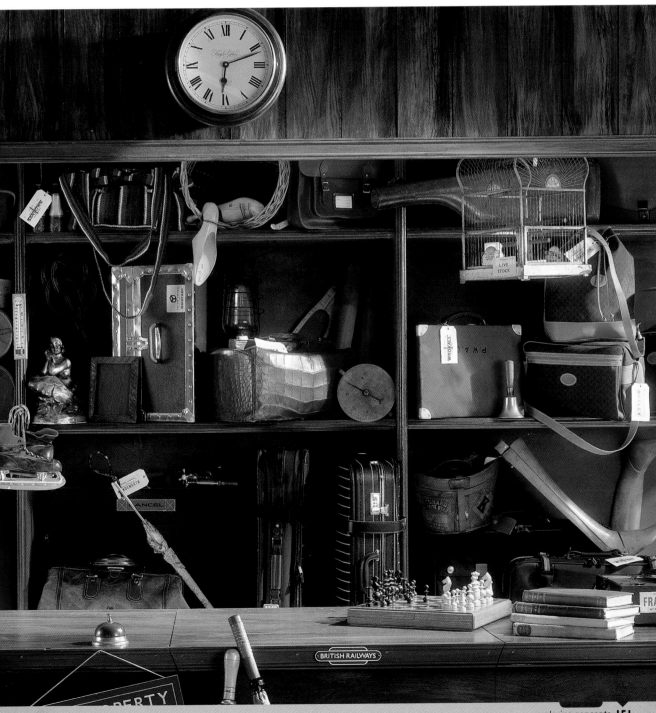

Photographer: **Jay Myrdal**

Client: **Ilford Master Class**

Use: **Lecture; subsequently placed in**
***Telegraph* library**

Assistant: **Marcos Lima**

Camera: **4x5in**

Lens: **150mm**

Film: **Kodak Ektachrome 6117 ISO 64**

Exposure: **f/32½**

Lighting: **Electronic flash: 6 heads**

Props and set: **Built set: see text**

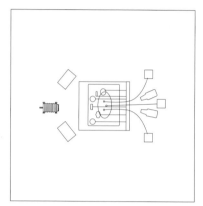

Plan View

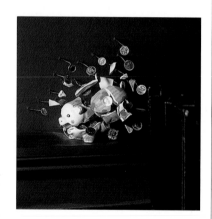

► *Mazov triggers can be set to react to pressure, sound, light and more*

► *There are often non-electronic ways of creating pictures which are apparently "comped" together*

EXPLODING PIG

▼

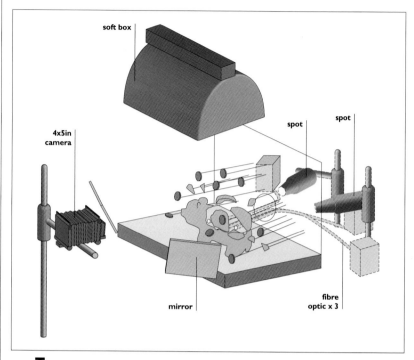

THIS IS AN IMAGE WHICH SCREAMS "COMPUTER MANIPULATION" – AND YET, IN ALL ESSENTIALS, IT IS AN ABSOLUTELY STRAIGHT SHOT CREATED IN CAMERA. THE ONLY COMPUTER MANIPULATION INVOLVED IS THAT THE COLOUR OF THE PIG WAS CHANGED AFTERWARDS . . .

The pig – including its fragments – and the coins were all part of a set built to camera, with concealed wires as shown in the set-up shot.

The main lighting came from two powerful spots, and three fibre optics, all coming through a hole in the background behind the pig: the intention was to get as much light "inside" the pig as possible. The only light from the front was a 45cm (18in) square soft box, although it was supplemented by mirrors to light specific areas.

Also passing through the hole was an air-line. Inside the pig, there was a little dust and some torn up paper. Releasing a trigger on the air-line also fired the flash via a Mazov trigger. The debris from the explosion is this dust and paper.

Photographer's comment:

We did this about 50 times at FOCUS, the annual UK exhibition, and then several more times in the studio. I also used this picture as a test-ground for my earliest computer manipulations, changing the colour of the pig and substituting other countries' coins for the British originals.

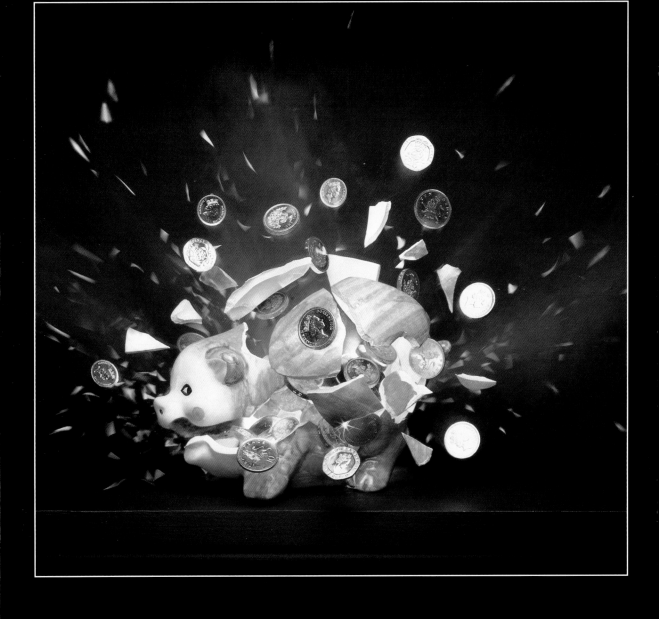

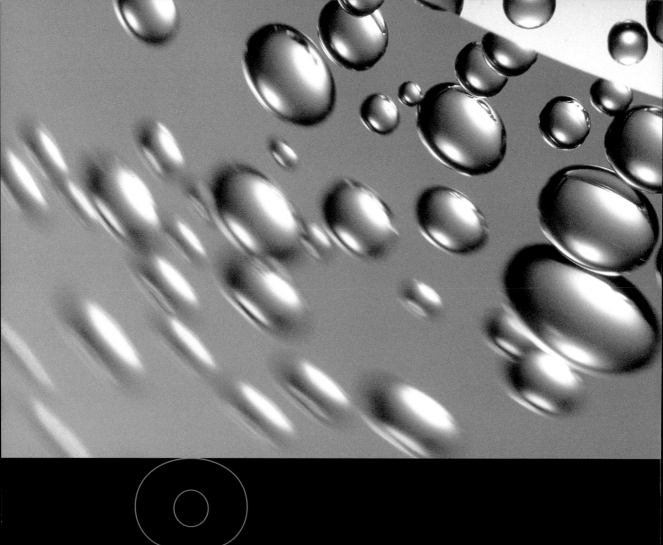

8

directory of
photographers

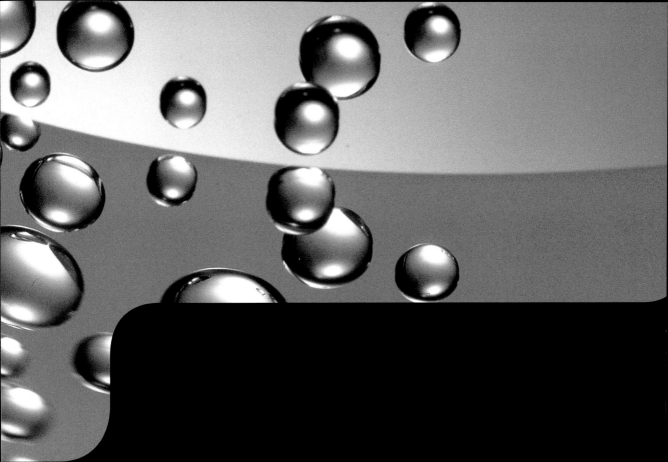

Photographer: **JOHNNY BOYLAN**
Address: THE SOAP FACTORY
9 PARK HILL
LONDON SW4 9NS
ENGLAND
Telephone: + 44 (0) 171 622 1214
Mobile Phone: + 44 (0) 831 838 829
Fax: + 44 (0) 171 498 6445
Biography: *Photography becomes a way of life, an obsession. Luckily for me it also provides a good living. Every new commission, whatever it is, is a challenge. That challenge need not necessarily be photographic. The sourcing of a location; a model; finding an unusual artefact; getting over the logistical problems of travelling to some backwater in another continent. Photography can be make-believe and fantasy, but most of all it is an art form of supplying your client. There is no room for error and there is no forgiving in supplying something that is unusable, whatever the reason. Enjoy!*
Still Lifes: pp79, 151

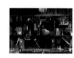

Photographer: **MARIA CRISTINA CASSINELLI**
Address: VENEZUELA 1421
(1095) BUENOS AIRES
ARGENTINA
Telephone: + 58 541 381 8805
Fax: + 58 541 383 9323
Agent
New York: BLACK STAR
116 EAST 27TH STREET
NEW YORK, NY 10016
Fax: + 1 (0) 212 889 2052
Biography: *Endowed with a unique creative style, Cristina represents with a clear identity and without spoiling the essence of the subjects, a still life, a portrait or an architectural oeuvre immersed in a landscape. One can recognize a directing thread, magical, in its diversity: innate sensitivity and a mature technique to combine in an image, aesthetics, light, design and subtle details ...*
Still Life: p111

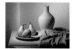

Photographer: **GUIDO PATERNÒ CASTELLO**
Address: AV. HENRIQUE DODSWORTH 83/1005
RIO DE JANEIRO 22061–030
Telephone: + 55 (0) 21 5218064
Fax: + 55 (0) 21 2870789
Biography: *Born in New York City March 19, 1958.*

Associate Arts degree at the American College in Paris: June 1979. Bachelor of Arts degree in Industrial and Scientific Photographic Technology at Brooks Institute of Photographic Arts and Science: June 1984. Presently working in Brazil as a commercial photographer. His clients are all major agencies based in Rio de Janeiro. He has won various awards including silver medal in 1992 and gold medal in 1993 at the Prêmio Produçao from ABRACOMP (Brazilian Association of Marketing and Advertising).
Still Lifes: pp55, 129

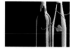

Photographer: **BENNY DE GROVE**
Address: FOTOSTUDIO DE GROVE
ZWIJNAARDSE STEENWEG 28A
9820 MERELBEKE
BELGIUM
Telephone: + 32 (0) 231 96 16
Fax: + 32 (0) 9 231 95 94
Biography: *Born 1957, he has been a photographer since 1984. Most of the time he works in publicity and illustration for magazines. For some time now he has been fascinated by triptychs. He likes to make his pictures somehow symbolic: they must be a starting point for discussion, for thinking about.*
Still Life: p139

Photographer: **JAMES DIVITALE**
Address: DIVITALE PHOTOGRAPHY
420 ARMOUR CIRCLE NE
ATLANTA
GA 30324
USA
Agent: SANDY DIVITALE, AT THE SAME ADDRESS
Telephone: + 44 (0) 171 622 1214
Biography: *Jim has been a commercial photographer since the late 1970s. His work has been recognized in such awards annuals as* Advertising Photographers of America Annuals One *and* Two, Graphics Photo 93 *and* 94, Print's Computer Art and Design Manual 3, *and* Print's Regional Design Annual *(1995) and he advertises in* Creative Black Book 1992–1995, Workbook Photography 17–18, Workbook's *Single Image #15–18,* Workbook's "Portfolio CD-ROM", Klik! Showcase Photography

2–4 and The Art Directors' Index to Photographers 20.
In 1995 Kodak sponsored Jim to lecture throughout the United States. Topics include digital photography for which he has won four national awards including a Kodak Gallery award. He was also invited to lecture at the World Council of Professional Photography and Imaging in Ireland in October 1995.
Still Lifes: pp35, 46–47, 50–51, 53, 85, 113

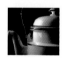

Photographer: **DAVID DRAY**
Address: 60 MILTON AVENUE
MARGATE
KENT CT9 1TT
ENGLAND
Telephone: + 44 (0) 1843 22 36 40
Biography: *He is a graphic artist working on the Isle of Thanet, Kent, England. He trained at the Canterbury College of Art, where he first started using cellulose thinners to produce montages from gravure printing. Later he applied the thinners technique to colour photocopies to achieve results as illustrated. He uses this technique with his own photography or (as appropriate) with other photographers' work to maintain complete control in design briefs.*
Still Life: p104–105

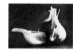

Photographer: **MICHÈLE FRANCKEN**
Address: N.V. FRANCKEN CPM
VLAANDERENSRAAT 51
9000 GENT
BELGIUM
Telephone: + 32 (0) 9 225 4308
Fax: + 32 (0) 9 224 2132
Biography: *Créer une ambiance avec la lumière et la composition. Travaillant beaucoup en location pour trouver plus d'intimité. Me sentant à l'aise bien en mode qu'en publicité. Cherchant le moyen technique d'émouvoir le spectateur!*
Still Lifes: pp39, 97

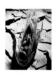

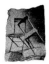

Photographer: **ROGER HICKS**
Address: ROGER & FRANCES
5 ALFRED ROAD
BIRCHINGTON
KENT CT7 9ND
ENGLAND
Telephone: + 44 (0) 1843 848 664
Fax: + 44 (0) 1843 848 665
Biography: *Wordsmith and photographer, both self-taught. Author of over 50 books, including this one; regular contributor to The British Journal of Photography, Shutterbug, Darkroom User and other photographic magazines. Has illustrated 'How-To' books, historical/travel books, and of course photography books. Works with his American-born wife, Frances E. Schultz, to provide words, pictures, or packages of words and pictures suitable for an international market.*
Still Lifes: pp71, 75, 141

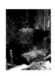

Photographer: **ANGELOU IOANNIS**
Address: AI – PHOTOGRAPHER
20 XATZILAZAROU STREET 546.43
THESSALONIUI
GREECE (STUDIO)
PO BOX 50797 – 54014
THESSALONIUI
GREECE (MAIL)
Telephone: + 30 (0) 31 813 772 (STUDIO)
Pager: + 30 (0) 31 237 400
Fax: + 30 (0) 31 238 854
Biography: *Commercial still life photographer, with clients throughout Greece. Teacher of photography and (recently) writer as well. Interested in alternative lighting techniques and/or combinations of different light sources. Involved in digital imaging. He likes to broaden his vision constantly.*
Still Lifes: pp100-101, 123

Photographer: **MARC JOYE**
Address: BVBA PHOTOGRAPHY JOYE
BRUSSELBAAN 262
1790 AFFLIGEM
BELGIUM
Telephone: + 32 (0) 53 66 29 45
Fax: + 32 (0) 53 66 29 52
Biography: *After studying film and TV techniques he turned over to advertising photography, where he found he had a great advantage in being able to organize the shoots. Now, he always prepares his shoots like a movie, with story boards to get the sales story into the picture.*
Still Lifes: pp43, 61, 121

Photographer: **KAZUO KAWAI**
Address: 5–7–1 OOI
SHINAGAWA-KU
TOKYO 140
JAPAN
Telephone: + 81 (0) 3 3777–7273
Fax: + 81 (0) 3 3777 7354
Still Lifes: pp66-67, 69

Photographer: **BEN LAGUNAS AND ALEX KURI**
Address: BLAK PRODUCTIONS PHOTOGRAPHERS
MONTES HIMALAYA 801
VALLE DON CAMILI
TOLUCA
MEXICO CP 50140
Telephone/Fax: + 52 (0) 72 17 06 57
Biography: *Ben and Alex studied in the USA, and are now based in Mexico. Their photographic company, BLAK Productions, also provides full production services such as casting, scouting, etc. They are master photography instructors for Kodak; their editorial work has appeared in international and national magazines, and they also work in fine art, with exhibitions and work in galleries. their work can also be seen in The Golden Guide, the Art Directors' Index, and other publications. They work all around the world for a client base which includes advertising agencies, record companies, direct clients and magazines.*
Still Lifes: pp19, 125

Photographer: **PETER LAQUA**
Address: MARBACHERSTRASSE 29
78048 VILLINGEN
GERMANY
Telephone: + 49 (0) 7721 305 01
Fax: + 49 (0) 7721 303 55
Biography: *born in 1960, Peter Laqua studied portraiture and industrial photography for three years. Since 1990 he has had his own studio. A prizewinner in the 1994 Minolta Art Project, he has also had exhibitions on the theme of Pol-Art (fine art photography) and on the theme of 'Zwieback' in Stuttgart in 1992.*
Still Lifes: pp143, 145

Photographer: **RON MCMILLAN**
Address: THE OLD BARN
BLACK ROBINS FARM
GRANTS LANE
EDENBRIDGE
KENT TN8 6QP
ENGLAND
Telephone: + 44 (0) 732 866111
Fax: + 44 (0) 732 867223
Biography: *Ron McMillan has been an advertising photographer for over twenty years. He recently custom built a new studio, converting a 200 year old barn on a farm site, on the Surrey/Kent borders. This rare opportunity to design his new drive-in studio from scratch has allowed Ron to put all his experience to use in its layout and provision of facilities including a luxury fitted kitchen. Ron's work covers food, still life, people, and travel, and has taken him to numerous locations in Europe, the Middle East and the USA.*
Still Lifes: pp26-27, 31, 107

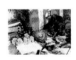

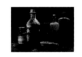

Photographer: **EROS MAURONER**
Address: ARICI & MAURONER FOTOGRAFI
VIA B. MAGGI 51/B
25124 BRESCIA
ITALY
Telephone: + 39 (0) 30 22 55 88 AND
24 24 212
Fax: + 39 (0) 30 22 55 88
Biography: *After years of experience in still-life photography, in design and architecture,*

he is now engaged with pictures of people, artists, singers. He doesn't like to specialize: versatility enables him to bring real excitement to whatever he undertakes. Part of him studies the project intellectually, while another part is just getting the feeling of it; somehow he can separate the two. Suddenly the solution appears, as if it were something he had never thought about. This helps him to infuse freshness into the final result. He is more attracted by ideas than by virtuosity, even if virtuosity subsequently becomes essential to realize the idea.

There's also something else of paramount importance in his professional life – having fun!

Still Lifes: pp93, 99

Photographer: **RUDI MÜHLBAUER**
Address: KREILERSTRASSE 13A
81673 MÜNCHEN
GERMANY
Telephone: + 49 (0) 89 432 969
Biography: *Geboren 1965, fotografiert seit frühester Kindheit, Ausbildung in Fotografenhandwerk, Spezialgebiete: Werbung, Stills, Landschaft, Reportage. Arbeit zur Zeit am Computer (Electronic Imaging und Retouching) für verschiedene Kunden und Werbeagenturen.*

Still Lifes: pp21, 41

Photographer: **JAY MYRDAL**
Address: JAM STUDIOS
11 LONDON MEWS
LONDON W2 1HY
ENGLAND
Telephone: + 44 (0) 171 262 7441
Fax: + 44 (0) 171 262 7476
Biography: *An American living and working in London since the middle '60s, Jay has worked in many areas of photography from editorial through rock and roll to advertising.*
His work remains wide-ranging, but he is best known for special effects and complicated shots; he works on a single image for many days if necessary. An extensive knowledge of practical electronics, computers, software and mathematics is brought into the service of photography when required, and he has a good working relationship with

top-quality model makers and post-production houses as well as working closely with third party suppliers. He has recently purchased a powerful electronic retouching system and expects to work more in this medium in the future.

Still Lifes: pp57, 91, 115, 131, 135, 153

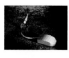 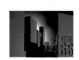

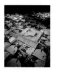 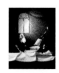

Photographer: **MAURIZIO POLVERELLI**
Address: VIA ENNIO 75
47044 IGEA MARINA (RN)
ITALY
Telephone: + 39 (0) 541 33 08 81
Fax: + 39 (0) 541 33 08 81
Biography: *Born in Rimini 30 years ago. He wanted to be a photographer even as a child, and so studied photography in Milan at the European Institute of Design followed by working as an assistant to Adriano Brusaferri, who specializes in food. In 1990 he opened his own studio in Rimini. Since then he has had some important advertising clients such as the Mario Formica calendar. Some of the images from this were exhibited in the Modern Art Gallery in Bergamo and in London. At present he works mainly in Rimini; in Milan he is represented by Overseas Agency.*

Still Lifes: pp33, 87, 89, 147, 149

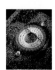 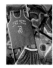

Photographer: **MASSIMO ROBECCHI**
Address: 44 BOULEVARD D'ITALIE
MC 98000 MONACO

MONTECARLO
Telephone/fax: + 33 (0) 93 50 18 27
Mobile: + 39 (335) 37 00 00 (GSM)
Biography: *Thirty-five year old Italian photographer. He moved to Monaco after several years working in Italy. Specialist in people and still life, represented world-wide by PICTOR INTERNATIONAL for stock photos.*

Still Life: p22-23

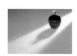

Photographer: **TERRY RYAN**
Address: TERRY RYAN PHOTOGRAPHY
193 CHARLES STREET
LEICESTER LE1 1LA
ENGLAND
Telephone: + 44 (0) 116 254 46 61
Fax: + 44 (0) 116 247 0933
Biography: *Terry Ryan is one of those photographers whose work is constantly seen by a discerning public without receiving the credit it deserves. Terry's clients include The Boots Company Ltd., British Midlands Airways, Britvic, Grattans, Pedigree Petfoods, the Regent Belt Company, Volkswagen and Weetabix to name but a few.*
The dominating factors in his work are an imaginative and original approach. His style has no bounds and he can turn his hand equally to indoor and outdoor settings. He is meticulous in composition, differential focus and precise cropping, but equally, he uses space generously where the layout permits a pictorial composition. His work shows the cohesion one would expect from a versatile artist: he is never a jack of all trades, and his pictures are always exciting.

Still Life: p29

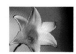

Photographer: **GÉRARD DE ST MAXENT**
Address: 14 BD EXELMANS
75016 PARIS
FRANCE
Telephone: + 33 (0) 1 42 24 43 33
Biography: *Has worked in advertising and publicity since 1970. Specializes in black and white but is also fully at home in colour.*

Still Life: p127

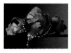

Photographer: **FRANCES SCHULTZ**
Address: ROGER & FRANCES
5 ALFRED ROAD
BIRCHINGTON
KENT CT7 9ND
ENGLAND
Telephone: + 44 (0) 1843 848 664
Fax: + 44 (0) 1843 848 665
Mobile: + 44 (589) 367 845
Biography: *American-born, British-based
photographer and writer. Specialist
in black and white, particularly travel,
and in hand colouring. Experienced
printer. Regular contributor to
Shutterbug and Darkroom User,
work also appears in other magazines
in Europe and the United States. Author
(with Roger Hicks) of numerous books,
mostly on photography.*
Still Lifes: pp73, 81

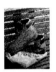

Photographer: **STRUAN**
Address: 60 HERBERT AVENUE
TORONTO
ONTARIO M4L 3P9
CANADA
Telephone: + 1 (0) 416 698 6768
Fax: + 1 (0) 416 698 3338
Biography: *"Intuition, simplicity and passion – these
are the ingredients I use to create the
images that keep me on the edge."
The early part of Struan's life was spent
mostly in Europe: London, Paris and
Geneva. After a year at Toronto's
Ryerson University in 1969, he opened
his own studio in Toronto in 1970, but
in 1989 he gave up his large studio and
full time staff, the better to operate on
an international level.
He has constantly been in the forefront
of beauty and fashion photography,
both advertising and editorial, and since
1982 he has also been directing
television commercials. He has won
numerous awards: Clios for advertising
in the US, Studio Magazine awards,
National Hasselblad awards, awards in
the National Capic Awards Shows. His
work has appeared in magazines in
Japan, the United States, Germany, and
Britain as well as Canada.*
Still Life: p133

Photographer: **RAYMOND TAN**
Address: EFFECT STUDIO
4 LENG KEE ROAD

THYE HONG CENTRE
SINGAPORE 0315
Telephone: + 65 (0) 479 41 73
Fax: + 65 (0) 479 47 64
Biography: *He started from scratch as an assistant.
It's been around ten years now, and he
prefers shooting products to fashion. He
strongly believes that photography is a
never-ending process of learning: no-one
can ever truly say that he is an expert
and has nothing more to learn.*
Still Life: p62-63

Photographer: **MATTHEW WARD**
Address: STUDIO SIX
9 PARK HILL
CLAPHAM
LONDON SW4 9NS
ENGLAND
Telephone: + 44 (0) 171 622 5223
Fax: + 44 (0) 171 720 1533
Biography: *Matthew Ward began his career as a
photographer having assisted several
advertising photographers and learning
the craft of studio management.
Coming to photography from a science
and engineering background has
enabled him to solve most of the
technical problems that he has come
across; particularly with respect to
lighting. The diversity of the work he
undertakes – everything except fashion
– enables him to look at each challenge
afresh and this varied experience has
equipped him with a variety of
techniques from which to draw when
creating images. He is very keen to
keep abreast of current developments
and is exploring digital imaging. Current
projects include a book on gardening
and a book on American Cars whilst
continuing to work for his corporate and
advertising clients.*
Still Life: p109

Photographer: **MARK WILLIAMS**
Address: ARK STUDIO
9 PARK HILL
LONDON SW4 9NS
ENGLAND
Telephone: + 44 (0) 171 622 2283
Fax: + 44 (0) 171 498 9497
Biography: *Mark Williams is an advertising
photographer shooting still life and
'lifestyle' photographs for clients
including Nokia, Shell and Max Factor.
For several years before specializing, he*

*spent most of his time travelling
throughout Europe, South East Asia and
North America for book publishers and
for magazines such as World of
Interiors; many of his images of people,
places, art and architecture are now
syndicated world wide by Tony Stone
Images. Mark is now based in London
at Ark Studio which he set up in 1994
in partnership with another
photographer and his girlfriend Siri, who
is an advertising stylist.*
Still Lifes: pp45, 83

 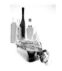

Photographer: **NICK WRIGHT**
Address: STUDIO SIX
9 PARK HILL
CLAPHAM
LONDON SW4 9NS
ENGLAND
Telephone: + 44 (0) 171 622 5223
Fax: + 44 (0) 171 720 1533
Biography: *After twenty years in photography, he
can turn his hand to most subjects
though he is probably best known for
his pictures of people and for still lifes.
He has photographed many celebrities,
and clients have included Which?
magazine, W.H. Smith, Nestlé and
E.M.I. Like any self-employed
photographer, he is always looking for
new and challenging commissions,
especially in landscape: he has
illustrated several books, wholly or in
part, most notably Daphne du Maurier's
Enchanted Cornwall.*
Still Life: p119

ACKNOWLEDGMENTS

For this, the third series of PRO-LIGHTING books, we must as ever give our greatest and most heartfelt thanks to all the photographers who gave so generously of pictures, information and time. We hope we have stayed faithful to your intentions, and we hope you like the book, despite the inevitable errors which will have crept in. It would be invidious to single out individuals, but it is an intriguing footnote that the best photographers were often the most relaxed, helpful and indeed enthusiastic about the series – though this is not the same thing as saying they were the ones with the most time to spare.

We also owe a considerable debt to Brian Morris, whose idea the series was, and we should like to thank the manufacturers who supplied the lighting equipment illustrated at the beginning of the book – Photon Beard, Strobex and Linhof and Professional Sales (importers of Hensel flash) – as well as the other manufacturers who support and sponsor many of the photographers in this and other books; we have mentioned them in the text or in the biographies wherever possible. Finally, Colin and Jenny Glanfield of The Plough Studios in London (a major hire studio, call + 44 171 622 1939) were as ever a constant source of help, ideas and introductions.